LOUGHBOROUGH PUBS

LYNNE DYER

AMBERLEY

For Bill Wells who led me in my first journey into local history, and to the people of Loughborough for ensuring our pubs continue to thrive!

First published 2023

Amberley Publishing
The Hill, Stroud
Gloucestershire, GL5 4EP

www.amberley-books.com

Copyright © Lynne Dyer, 2023
Maps contain Ornance Survey data.
Crown Copyright and database right, 2023

The right of Lynne Dyer to be identified as
the Author of this work has been asserted in
accordance with the Copyrights, Designs and
Patents Act 1988.

ISBN 978 1 3981 1343 5 (print)
ISBN 978 1 3981 1344 2 (ebook)

British Library Cataloguing in Publication Data.
A catalogue record for this book is available from
the British Library.

Typesetting by SJmagic DESIGN SERVICES, India.
Printed in the UK.

Contents

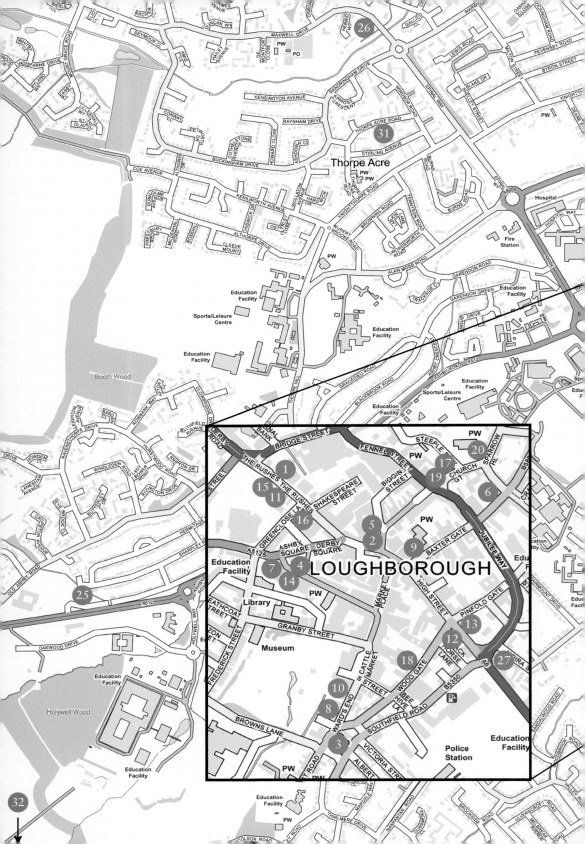

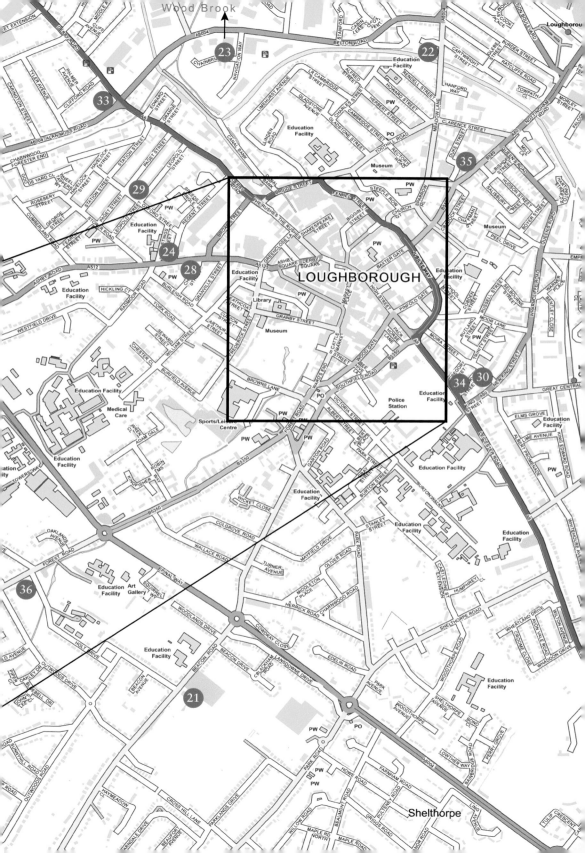

Key

Town Centre

1. Amber Rooms, The Rushes
2. Bell Foundry, Swan Street
3. Blacksmith's, Ward's End
4. Cask Bah, Market Street
5. Champs, Biggin Street
6. Fat Sam's, Sparrow Hill and Baxter Gate
7. Griffin, Ashby Square
8. Jam Garden, Ward's End
9. Loughborough Arms, Baxter Gate
10. Moon & Bell, Ward's End
11. Needle & Pin, The Rushes
12. Organ Grinder, Wood Gate
13. Phantom, Leicester Road
14. Project, Market Street
15. Swan-in-the-Rushes, The Rushes
16. Tap & Clapper, The Rushes
17. Three Nuns, Church Gate
18. Wheeltapper, Wood Gate
19. White Hart, Church Gate
20. Windmill, Sparrow Hill

Beyond the Town Centre

21. Beacon Inn, Beacon Road
22. Boat Inn, Meadow Lane
23. Charnwood Brewery, Jubilee Drive
24. Generous Briton, Ashby Road
25. Harvester Wheatsheaf, New Ashby Road
26. Maxwells, Maxwell Drive
27. Moonface, Moira Street
28. Old English Gentleman, Ashby Road
29. Paget Arms, Paget Street
30. Peacock, Factory Street
31. Plough Inn, Thorpe Acre Road
32. Priory, Nanpantan Road
33. Ring O' Bells, Derby Road
34. Royal Oak, Leicester Road
35. Tap & Mallet, Nottingham Road
36. Toby Carvery, Forest Road

Introduction

To write a book about the history of the pubs in Loughborough is to follow in the footsteps of giants. Eric Swift in his short booklet *Inns of Leicestershire*, written in 1976, covers a remarkable amount of ground, both geographically around Leicestershire and historically through the ages of the drinking establishment. Unlike Swift, Bill Wells in his 2013 publication *Billy's Book of Loughborough Boozers* focuses solely on drinking establishments of Loughborough, both past and present, tracking name changes through the ages and including a variety of complementary information. *Loughborough Pubs* combines the two approaches, taking as its focus drinking establishments in Loughborough which were in existence immediately before the pandemic of 2020–22, and those that have since re-opened, tracing their history and fortune, and being scattered with interesting information.

In 1770, it is recorded that there were forty-three licensed inns and beerhouses in Loughborough, which grew to fifty in 1783, when the town population was just under 3,000. The beginning of the nineteenth century saw a large growth in population, which levelled off mid-century, growing again in the latter part of the 1800s, accompanied by an increase in the number of drinking establishments. In 1888, the year of incorporation, it was reported at the Loughborough Petty Sessions that there were 158 alehouses, a further fifty-one on-site licences, forty-three off-licences, and eleven wine licences, making a grand total of 263 licences to sell alcohol to a population of around 15,000. This compares to 260 in the previous year, 264 in 1889, and 262 in 1891. When researching for the first edition of his book, Wells discovered the number of pubs to be only fifty-six, and noted that by the time of his second edition only forty-three remained. Ironically, considering that Loughborough is a market town, there are no longer any establishments in the Market Place.

As well as the many pubs, taverns, coaching inns, post-houses, and beer or ale houses in Loughborough, the town was once home to the extensive Midland Brewery Company on Derby Road, close to the canal. Many of these establishments have been lost, but a brief consideration of these offers a tantalising glimpse into the history of the town.

The Bishop Blaize, named after the patron saint of woolcombers and wool workers, which was the primary industry in Loughborough during the medieval period, now demolished. The Barley Mow, situated on what is now Market Street, but previously known as (Malt) Mill Lane, now divided into a café, a microbrewery, and a retail unit. The Cherry Tree, built on what used to be a cherry orchard, now demolished and replaced with flats. The Fox and Hounds, the Hare and Hounds, and The Fox, all reflecting the close connection with the nearby Quorn Hunt, all now gone. The Railway Inn, demolished, the Station Hotel, now a funeral parlour, and the Great Central Hotel, now a day nursery and residential flats, all built during the heyday of the railways.

Other establishments now closed paint the more national picture: the George the Fourth, the Marquis of Granby, the Duke of York, and the Royal George – all lost. Gone too are some of the most popularly named establishments, amongst which are the Bull's Head, a former coaching inn, the building replaced during a period of road

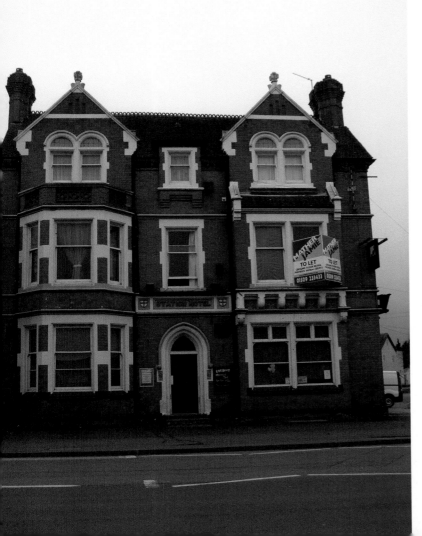

Station Hotel for sale, 2015.

widening, and now housing a café; the King's Head, most recently a hotel; the Blue Boar and the Red Lion, both demolished; the Three Horseshoes, the Black Horse, the Angel, the Victoria, and the Nelson, no longer pubs. The Clarence converted to short-stay accommodation; the Gate converted to flats; the Cooper's Arms, flattened for road widening; the Greyhound converted to a boutique boxing studio with protein kitchen; and the White Horse, a restaurant. The Druid's Arms has been a centre for martial arts for a few years, but planning permission has been sought for conversion to flats.

In late 1809 to early 1810, the Earl of Moira auctioned much of his land and property in Loughborough, where he was lord of the manor, to clear debts and to fund coal mining on his lands in north-west Leicestershire. Included in the first of these sales between Tuesday 14 and Friday 17 November 1809, comprising 252 Lots, were many pubs, beerhouses, and coaching inns.

According to Swift, 'Loughborough has always been lavishly endowed with inns, taverns and beerhouses; its position on the coach road and canal, its market and manufacturers, all attracting thirsty travellers.' However, as railway travel displaced coach travel, coaching inns became redundant, but Loughborough's vibrant general and specialist markets and former cattle market have ensured that many drinking

The Gate, Meadow Lane, converted to flats in 2017.

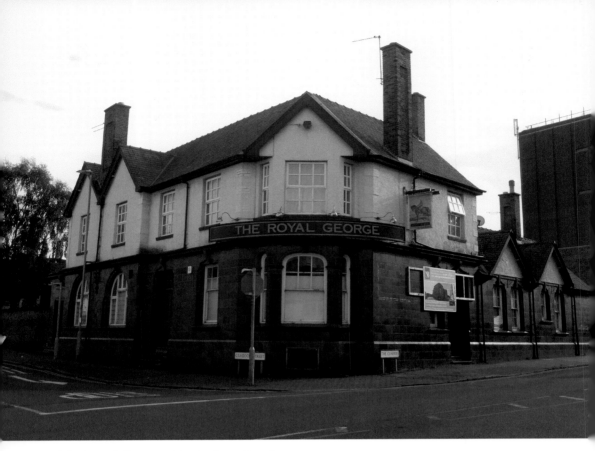

The Royal George, Nottingham Road, 2017.

establishments survived well into the twentieth century before finally closing their doors. Swift goes on to say, it is important that we 'wonder not at the numbers [of establishments] that have perished, but the beauty and attraction of those that have survived'.

And so, to some of those survivors…

<p style="text-align:center">I</p>

Town Centre Pubs

1. Amber Rooms, The Rushes

When a new shopping area was created in Loughborough, which spanned the area from The Rushes to the top end of Biggin Street, provision was made for a new pub. The first stage of this work was completed in 2003, and the Amber Rooms, a Wetherspoons venue, opened its doors. The building had been constructed on the site of what was the former Electricity Works and offices of the Borough Electricity Department. The electricity buildings had themselves replaced buildings like the Rising Sun lodging house, a place offering rooms to travellers and to the homeless to avoid them going to the workhouse. The area was hit by a Zeppelin bomb in 1916, and in 2016 a commemorative plaque was placed next to the Amber Rooms at the bottom of the stairs that lead from The Rushes to the shopping complex.

The connection with electricity is continued in the name of the pub, as the Greek word '*elektron*', from which electricity takes its name, means 'amber'. A busy pub,

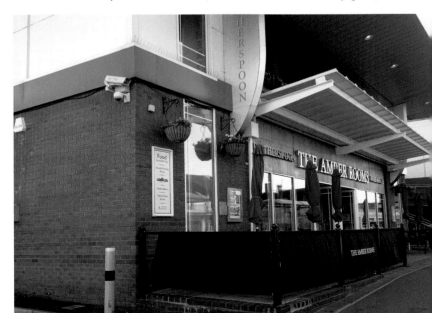

Amber Rooms, 2022.

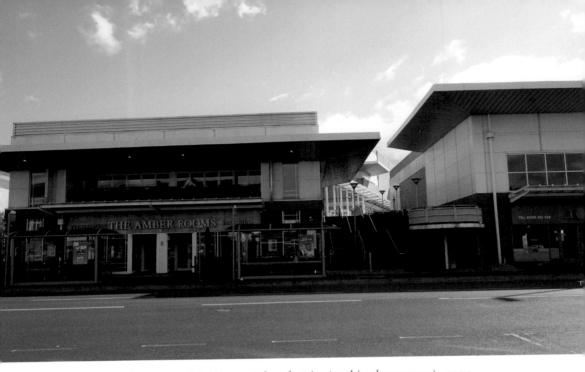

Above: Zeppelin memorial plaque right of stairs (and in the tarmac), 2022.

Below: Amber Rooms patio, 2022.

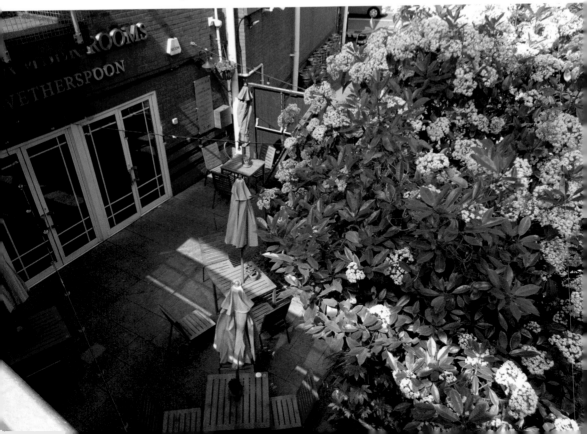

the Amber Rooms was awarded the Casque Mark in 2005. The building fronts onto The Rushes and has a patio area at the rear, which is accessed via the pub. The patio sits next to the Wood Brook, close to the pedestrian bridge into and out of the shopping area.

Since its re-opening following the pandemic, in November 2021, the Amber Rooms has won a platinum award in the Loo of the Year Awards, and due to the success of the outside patio area, a planning application has been submitted to enlarge and improve this, which includes taking in the Wood Brook.

2. Bell Foundry, Swan Street

The Bell Foundry is named in honour of the sole remaining dedicated and working bell foundry in the country, which is in Loughborough. The pub pre-dates the arrival of the bell foundry to the town, as the Old Saracen's Head public house was listed in the Earl of Moira's 1809 sale. Lot 129 comprised a newly built property, with a brewhouse, stables, sheds, and a yard, having a 10-foot-wide gateway at one end. Later, in an auction held in 1872 at the Saracen's Head, the pub itself was being sold, and now comprised a bar, a taproom, a club room, a kitchen, a scullery, and thirteen bedrooms! There were also cellars, a large yard, a brewhouse, a washhouse, granaries, stabling for nineteen horses, and piggeries!

Auctions of other properties and land were also held at the pub, but it was itself again auctioned in 1878. The pub had undergone several changes since it had previously been sold and now had a separate dining room with a private sitting room, while the number of bedrooms had reduced to eleven. Outside included a six-stall stable with lofts above, a covered carriage shed, a saddle room, loose boxes, and a bowling alley. The frontage was extensive and was advertised in the '*Leicester Journal*' as being 'situated in the best position in the town on the main road from Leicester to Derby'.

During the 1920s and 1930s, much of Loughborough town centre was developed and improved, older properties demolished, streets widened, and new properties built. The Saracen's Head was demolished and rebuilt, but while new properties nearby embraced the Art Deco faience tile cladding, from local company Hathernware, the pub was a traditional black and white design, and its roof clad in the local slate tiles from Swithland.

Local material was also used in the creation of a memorial commemorating the site where a Zeppelin bomb fell nearby, on The Rushes in 1916: granite from nearby Mountsorrel was fashioned into a cross and mounted into the tarmac. Following the Zeppelin attacks across the country, and only a few weeks before Loughborough itself was targeted, in early 1916 a New Lighting Order had come into effect. Citizens were expected to extinguish all lights, and draw down the blinds, something which, later in 1916, the landlord of the Saracen's Head, had not done, and so he was fined 7s. 6d. for using a flashlight indoors, which could be seen from outside the premises.

Throughout its existence, various groups held their annual dinners at the pub, including the Loughborough and District Wheelers (cycling club); staff from Tucker's brickworks; the William Moss Sports club, and employees of Fuller and Hambly, hosiers of Hathern. The Licensed Victuallers' Association also held some of their meetings and

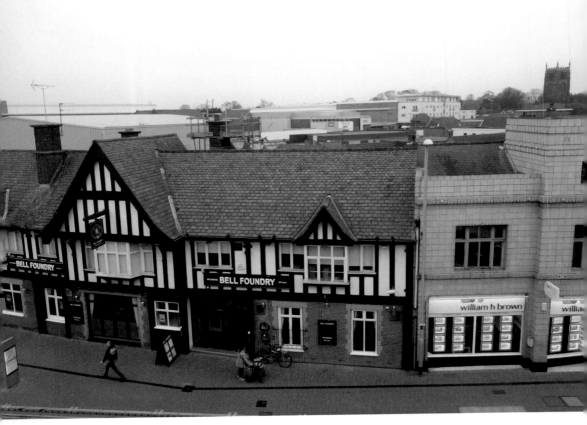

Bell Foundry and art deco building, 2017.

events at the Saracen's Head, and at their annual meeting, on 22nd January 1936, the menu cards carried a black border, a mark of respect for King George V, who had died two days earlier.

In 1836 a well-known trotting horse called Rattler, the subject of a painting by prolific animal painter John Frederick Herring (senior), stopped by the pub, for the purpose of mating with local mares. In 1935, 70 members of the Leicester City United Trades' Whist league played a friendly match at the Saracen's Head, which included many players from Loughborough teams – the Constitutional Club; St Peter's; Brush; Morris South Works; Morris North Works; Messengers; Beacon Sports; Cottons; Liberal Club; Foresters; Willowbrook; Catholic Club; British Legion; Granby Park; and the Territorials. The outcome was that Loughborough won by 24 to 10.

Draws for the local bowls cups – the Mallinson Shield and the Hartopp Cup – at one time took place in the Saracen's Head, as did the draw for the 4th round of the Midland Individual Darts Championship. Included in the latter were only two women players, Mrs Walker of Syston, and Miss Hilda Dormer, a Loughborough councillor who would later become the first woman mayor of the town, who were drawn against each other: Miss Dormer was victorious.

Music was also a big part of the pub's offering, and as early as 1886, Francis Noakes was looking for a pianist for the venue, as was Mr Ulyatt in 1958. The granting of the music licence in 1918 had been controversial, as there had reportedly been occasions when venues holding such a licence had stayed open until 11 p.m., rather than to the regulatory 9.30 p.m. of the time.

More recently, the pub has changed name: to Casablanca in the 1980s; The Gallery in 1999, and finally to the Bell Foundry in 2017. Following a period of national closure, the pub re-opened on 4 July 2020.

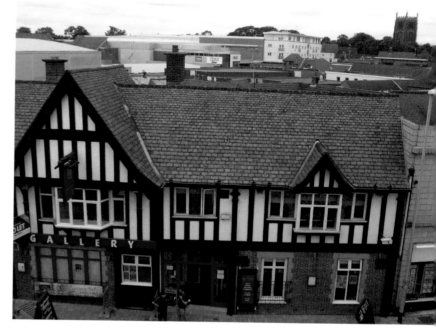

Gallery, 2014.

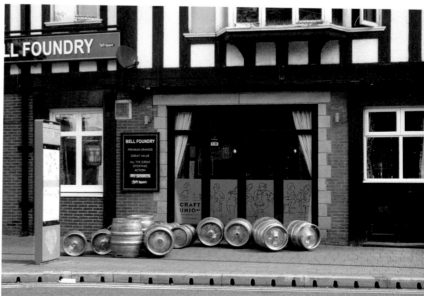

Bell Foundry – business as usual, 2022.

3. Blacksmith's, Ward's End

In its earlier days, the Blacksmith's was known as the Black Boy, possibly after Charles II, maybe after local chimney sweeps or miners, or perhaps after the local Burnaby family, whose crest included such a figure. Although the Royal Victoria Lodge of the Order of Druidesses held their inaugural, and early meetings at the Mundy Arms (now Fat Sam's), they held their 12th anniversary meeting in June 1854, in a room on Moira Street. More than ninety members sat down to tea, after which some of the younger members went on to the Black Boy pub, where they were able to dance for the whole evening.

By the 1860s, the Birkin family were living at the Black Boy, where innkeeper Joseph was also a blacksmith by trade. After a period as landlord of the Windmill, Joseph's son, Luke, also a blacksmith, followed in his footsteps and was innkeeper at the Black Boy by the early 1870s. Joseph died in 1876, and it was around this time that the Black Boy was renamed the Blacksmith's Arms. During the 1880s there were a variety of landlords, until the Holmes family took over, and remained in charge of the Blacksmith's Arms until at least 1952.

In 1929, during the time Sydney Holmes was landlord, the licence for the Blacksmith's Arms was renewed, on the condition that the building was re-built within two years. The following year, the plans for the new building were approved, and work began. However, when the licence was up for renewal again, in 1931, objections were made because the building work was not completed. The explanation that the weather had severely held up the works, and the assurance that the work would be complete within 18 weeks, meant that the licence renewal was adjourned for a month, when progress would again be reviewed.

As we know from the pub we see today, the building *was* completed in 1931, and in some style! The Art Deco movement was in full swing, and Hathernware, the local company making faience tiles, was in its heyday. Thus, the new, tiled Blacksmith's Arms was as fashionable as it was possible to be, and proudly displayed its construction date and blacksmithing tools on the front of the building.

In 1960 there was excitement at the Blacksmith's Arms when an American civilian, on classified secret work, stayed at the pub, and in the course of this work travelled over 7,500 miles across Britain in four months! Mrs Wood, the proprietor of the Blacksmith's Arms in 1972, was advertising bed and breakfast in a centrally heated room for £1.62 1 / 2p ! In 1977 the pub was listed in the CAMRA guide, 'Real Ale, Leicestershire & Rutland', and like many other Loughborough pubs, the Blacksmith's fielded darts teams, had a skittle alley for hire, and was a venue for wedding receptions.

In 1991 the pub was refurbished, meals were offered, and the skittle alley was also available to hire. In the twenty-first century, the internal configuration was changed, and the wall between the two separate rooms taken down, to provide one large space, while the skittle alley was converted to a function room.

The name of the pub remained as the Blacksmith's Arms until about 2002 when it changed to Voodoo. There then followed a quick succession of names, including Smiths, and @TheOffice. In 2004 the building was added to the Borough Council's register of locally listed buildings, and in 2009 it became an Indian restaurant, firstly

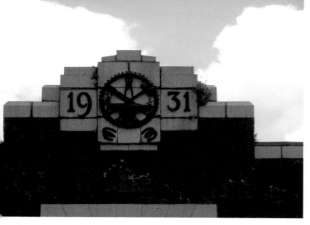

Above: Date and blacksmithing tools on the Blacksmith's, 2022.

Right: Blacksmith's art deco detail, 2022.

Below: Blacksmith's, side view, 2022.

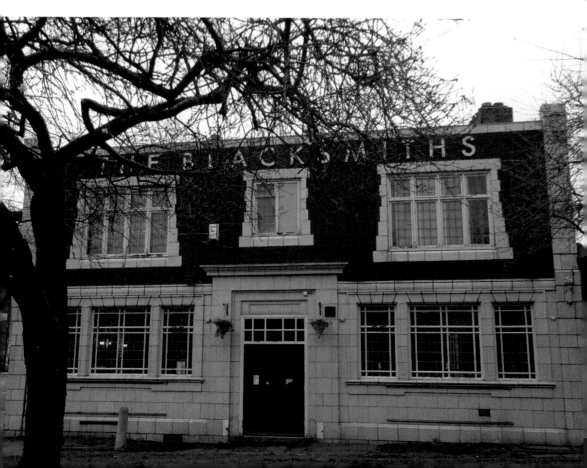

Liquid Spice, then Kesar, before reverting to its function as a public house called Baroque, and finally, the Blacksmith's. As Wells says, this is the Loughborough pub that has probably had the most name changes during its lifetime, along with, perhaps, the Loughborough Arms!

4. Cask Bah, Market Street

The Cask Bah is a music micropub which opened in July 2018, and is housed in what appears to be the middle of a mock-Tudor, 1930s property, which is at the end of a run of distinct but restrained art deco buildings. However, it hasn't always been this way...

Back in the nineteenth century, the Barley Mow, a Home Ales pub, occupied a two-storey brick property with a separate single-storey billiards and snooker hall to the left. Early landlords have included the three Thomases – Thomas Mills, Thomas Williams, and Thomas Fisher. Not only did Samuel Jones break the mould, but in 1917 he had a nasty accident and broke his arm in two places, and sustained some deep cuts to his face, when, on the way to Quorn, the pony pulling his trap bolted. This was just days before Samuel and his wife, Frances, received the devastating news that their son, Randolph, had been killed in action in the First World War. Shortly after this, in 1918, Samuel was selling off his billiard tables, and by 1919, W. Davies had become landlord.

And so it was that in the 1930s, during a period of street widening, the building housing the Barley Mow was demolished and rebuilt in mock-Tudor style, with a gable end to the left and gated access, further to the left, leading to the rear. In the late 1960s, the electric pumps whirred away, delivering a serving of Home Ales beer. In 1972, popular brother and sister team Jack Birch and Audrey Bullock took over the pub, and remained there until 1990. During their time, the Barley Mow appeared in *Nicholson's Real Ale Guide to the Waterways* (1976), described thus: 'A large, single-bar affair redecorated in mock-Tudor style. Well worth a lunchtime visit for its cold food. Home Ales, mild and bitter served by electric pump. 300 yards south of the basin.' The Barley Mow was also listed in the 1977 CAMRA *Real Ale, Leicestershire & Rutland* guide.

In 1985, the pub hosted carol singing when the Loughborough Rotaract Club held a charity event inside, and a three-legged pub crawl raised £400 for cancer research. The Barley Mow quiz team came second when they were one of twenty-seven teams to take part in a Loughborough Round Table Quiz in 1991, losing to 'Corporation A' in a tie-break.

In 2002, the Barley Mow was renamed Barleys, but closed for good in 2004, the same year it was added to the Borough Council's register of locally listed buildings. Since that time the building has seen an addition to its left, replacing the former double gate that led to the back, and the premises have been occupied by a variety of businesses, including three different cafés, an estate agent, and clothing shops. In 2018, the middle section of the building was opened as Cask Bah, a microbrewery and lively venue that hosts regular music events, and which is decorated with music memorabilia. Much use has been made of the outside seating, especially since the pandemic.

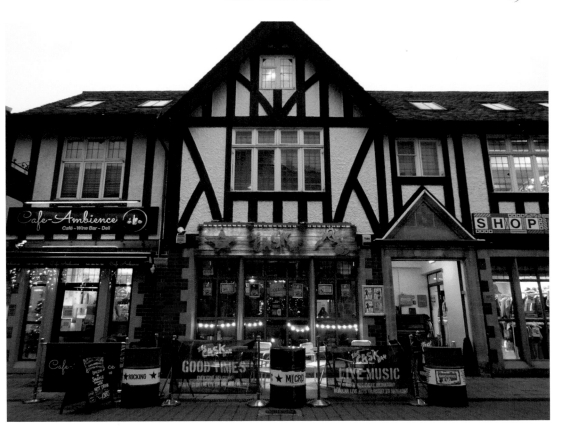

Above: Cask Bah, 2022.

Right: Inside the Cask Bah, 2022.

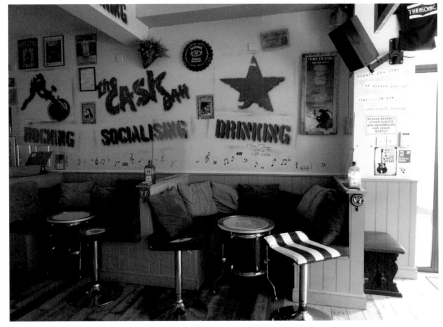

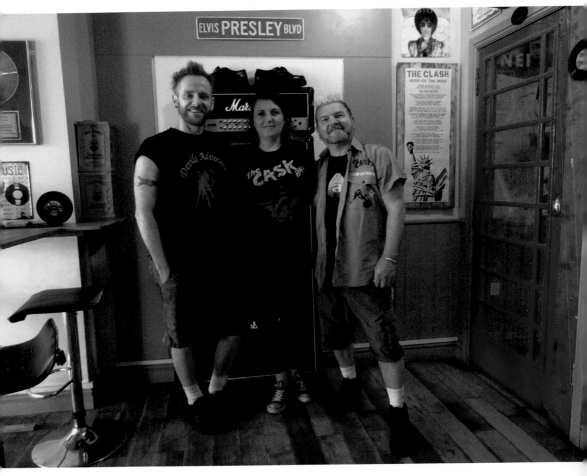

Rich, Nat and Craig at the Cask Bah, 2022.

5. Champs, Biggin Street

Lot 127 in the Earl of Moira's sale in 1809 was the Unicorn public house, described as being a newly built house with good stables, outbuildings, yard, and a garden. At the time of the sale, the Unicorn was in the occupation of Mr William Withers, who sadly died the following year. In 1897, alterations were done to the building, and in January 1919 the General Purposes Committee of the Loughborough Town Council met to discuss the purchase of the buildings between Swan Street and the Unicorn Hotel to facilitate street widening. By April that same year, the council also wished to purchase some of the property associated with the Unicorn, and it is this new building and new layout that remains today.

In 1986, the Bass brewery applied to relinquish the licence held by The Nelson in Market Place and transfer this to a new pub on the Gorse Covert estate, at the same time pledging to spend £100,000 on refurbishing the Unicorn. The pub duly closed in February 1987 and re-opened in August that year, having had a makeover costing

£200,000! A further refurbishment happened in 2010, followed by a period of closure and re-branding in 2018, when the Unicorn became Champs.

As the Unicorn, the pub always had a strong connection to sport, and over the years had been the meeting place for the committees of the North Leicestershire Cricket League, Loughborough Football League, the Loughborough marathon, the Homing Pigeon Society, the Leicestershire Association of Referees, and became an examination centre for football referees.

Rooms at the Unicorn were also used as meeting spaces for the Chartists, the Licensed Victuallers' Association, the Typographical Association, the Pride of Loughborough Lodge of the Sheffield Equalised Independent Druids, and the Buffaloes from the Victory Lodge, three Leicestershire Lodges, and some Grand Lodge of England Lodges. Like many of the older pubs in Loughborough, the Unicorn was also the venue for auctions and inquests.

The Unicorn was listed in the 1977 CAMRA guide *Real Ale, Leicestershire & Rutland*. The re-branding to Champs happened only shortly before the pandemic hit, but the pub successfully re-opened on 4 July 2020.

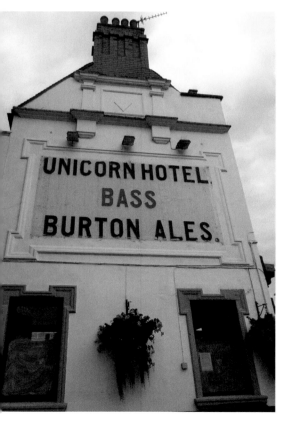 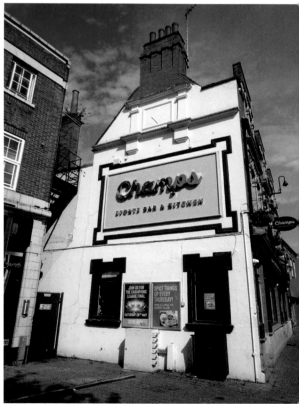

Above left: The Unicorn is revealed, 2018.

Above right: Champs replaces the Unicorn, 2022.

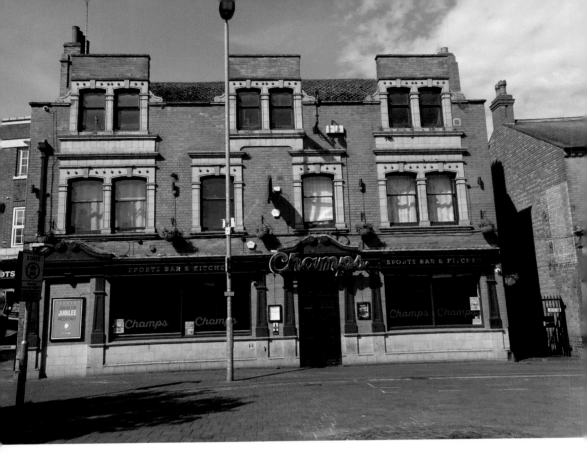

Champs, 2022.

6. Fat Sam's, Sparrow Hill and Baxter Gate

When Lot 55, the Grey Horse public house, was sold at the Earl of Moira's sale in 1809, it was described as a brick and slate building with stabling for twenty horses, a brewhouse, outbuildings, a large yard, and a tenement occupied by William Cooper. The property was listed as spanning the corner of Sparrow Hill and Baxter Gate. By 1832, the new owner, James Remington, who had previously worked as butler to the Mundy family, of nearby Burton-on-the-Wolds, changed the name of the Grey Horse to the Mundy Arms.

When in 1876 the Mundy Arms was auctioned at the King's Head, it was advertised in the *Nottinghamshire Guardian* as situated 'in the important thriving town of Loughborough, and possess[ing] two good frontages, one to Sparrow Hill of 56 feet, and the other to Baxter gate of 83 feet, and containing in the whole an area of 516 square yards or thereabouts, and within five minutes' walk of the railway station'. This distance from the railway station was clearly important because when the Midland station was opened in 1840, the *Midland Counties' Railway Companion* carried an advert for James Remington's establishment that read: 'Good beds and extensive stabling', with a 'double-bodied phaeton to let or hire', stressing that the 'omnibus to and from the Station passes within a few yards of the door'.

Like similar establishments during the nineteenth century, the Mundy Arms was the venue for inquests and auctions of land and property. The Stag and Pheasant pub on Nottingham Road was auctioned here in 1843, as was land and property in nearby villages like Seagrave and East Leake. The pub was also a meeting place for a wide variety of groups, and in 1842, the Royal Victoria Lodge of the Order of Druidesses held their inaugural, and subsequent, meetings in the Mundy Arms. Similarly, in 1865, what was to become known as the Loughborough Soar Angling Society held their first of many meetings in the pub. The Licensed Victuallers' Association also held some of their meetings within. Anniversary dinners in celebration of the Battle of Waterloo and of the Ancient Order of Corks also took place at the Mundy Arms.

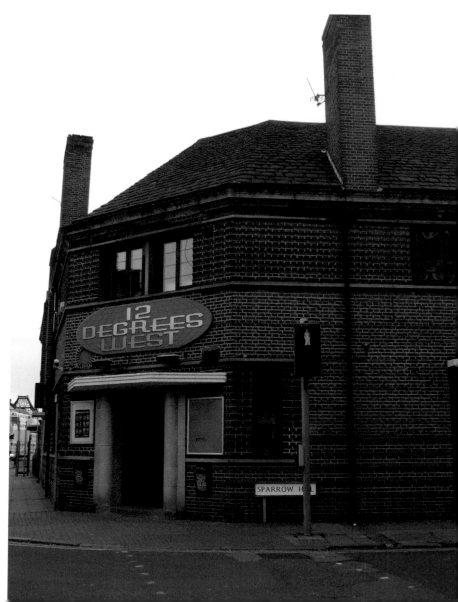

12 Degrees West, 2015.

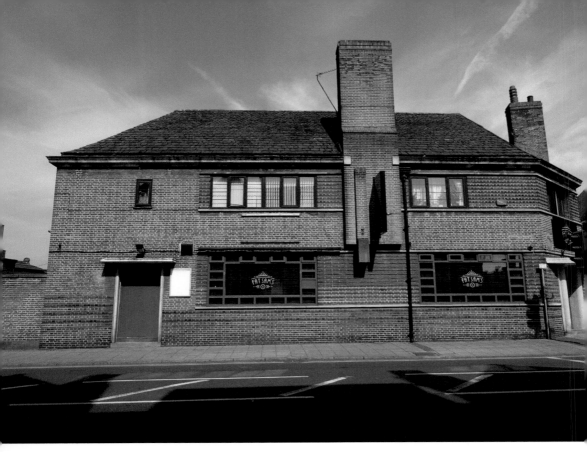

Fat Sam's from Baxter Gate, 2022.

When Queen Victoria and Prince Albert's son, Prince Edward, married Alexandra of Denmark, Loughborough celebrated and the Mundy Arms was bedecked with an array of beautiful evergreens bearing the slogan 'Long live the Prince of Wales'. In more recent years, the pub has been the venue for wedding receptions.

In 1935, plans were submitted to the council for a new building, and this resulted in the building we see today, with its entrance being exactly at the point where Sparrow Hill and Baxter Gate meet. The building was added to the Borough Council's register of locally listed buildings in 2004. As well as building, lighting and signage changes, the pub has also gone through a number of name changes – Flan O'Briens (1997), Bar 32 (2000), 12 Degrees West (2002) – to become today's Fat Sam's around 2017–18. After a period of closure during the pandemic, the pub re-opened on 4 July 2020.

7. Griffin, Ashby Square

The Griffin was auctioned in the Earl of Moira's sale in 1809 as Lot 162, the description stating it was a public house with a good yard and garden, situated on what was then Bear Place (now Ashby Square), at the junction of Mill Lane (now Market Street) and Cockpit Row (now Derby Square). The pub was again auctioned in 1863 at the Town Hall, when it was described as a well-known and old-established inn with good

gardens, stabling, a coach house, a granary, a brewhouse, and other outbuildings, all belonging to Harry Harridge. The first offer made was for only £500, but was then increased to £815. However, as the reserve price of £850 was not reached, the Griffin was not sold. By comparison, other pubs which were also in this same auction – the Blue Boar and the Duke of York, both now demolished, and the Nelson, now a café – were all sold for well above their expected price.

Auctions of land and property took place within the Griffin, but between 1851 and 1871 there were also many auctions of stocking frames, ranging from two frames to seventy frames, often because their owners, like Mr Corbett and Mr Constable, were bankrupt. An inquest into the death of a hosiery factory worker whilst at work took place in the Griffin, as did many other inquests, including one into the death of forty-seven-year-old George Mounteney, a local coal merchant who was crushed by a cart whilst trying to steady a skittish horse. This would have been a sad reminder for the family of the recent death of Mounteney's son, who was crushed to death between two railway carriages at the Midland railway sidings.

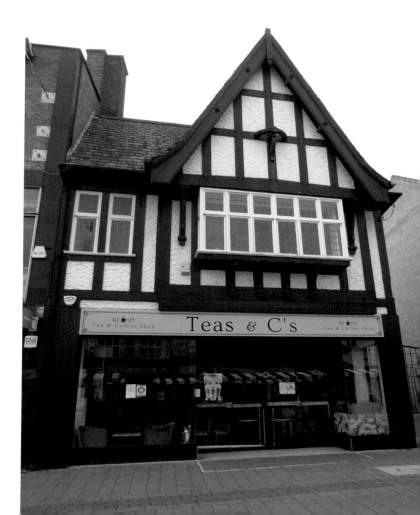

Former Nelson, 2021.

As with many other pubs, sport has been important at the Griffin. Perhaps at one time, bearbaiting *might* have taken place, but what is certain is that in the early 1800s, pigeon shooting was popular. In 1850, around 7,000–8,000 people came from as far as York and London to watch a running race which took place along Ashby Road. The two competitors were Westhall, who was staying at the Stag and Pheasant (now a shop), and Roberts, who was lodging at the Griffin. Well-known competitors amongst the spectators included residents of Turnham Green, notably Samuel Smith, who would later become the landlord of Loughborough's Three Crowns, now the Tap & Mallet. Nearly 100 years later, Griffin landlord Harry Cutter along with friend Noel 'Buddy' Thomas formed the Griffin Boys' Boxing Club, which later became the Morris Sports Boxing Club, an important group on the local amateur boxing scene. The Griffin has also been involved in cricket, table skittles, cribbage, football, and darts, while the Fur and Feather Show has exhibited at the pub, and the District Canine Society has held matches within. Many fundraising events have also taken place at the Griffin.

The pub was listed in both the 1976 *Nicholson's Real Ale Guide to the Waterways* and the 1977 *Real Ale, Leicestershire & Rutland* CAMRA guide, and in 1984 was awarded a Grade II listing in the national register of listed buildings. In the 1990s, the

Griffin, 2017.

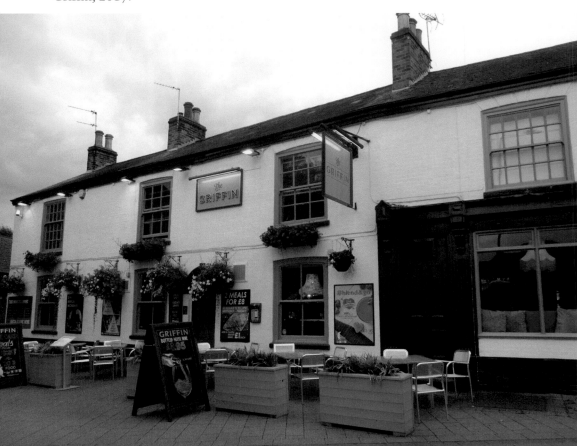

landlord won awards for being the Top Profit House for Marstons brewery, and twice won a prize in the nationwide competition to sell the most Murphy's stout, selling 1,400 gallons in 1994. The pub also won an award in the 2019 Loughborough In Bloom contest.

Car parking at the pub was improved in 1988, and in early 1989 the pub closed for a period while a conservatory was installed at the rear. Further alterations to both the interior and exterior, which saw two rooms knocked into one, and a period of closure for a £300,000 refurbishment have ensured that the premises remains popular with both the student and local population.

8. Jam Garden, Ward's End

As early as 1813 the Wheatsheaf was a venue for auctions, either of property, for example on New Street and Ward's End, or of objects, like twist lace machinery in 1827. Like many other licensed premises in the nineteenth century, the Wheatsheaf hosted inquests into deaths. One inquest of particular interest took place in 1852 and caused some consternation with the jury, as this was the first inquest to be held in Loughborough following the abolition of fees for jury members: unaware of this, some jurors were unhappy.

The Wheatsheaf was also a regular meeting place for various groups, and the Loughborough Lodge (United Brethren No. 18), part of the Nottingham Ancient Imperial Order of Oddfellows, was formed in September 1832 at the pub. By 1862, the Loughborough Lodge had more than 195 members, who looked after the health and welfare of their members by each paying into a scheme from which they could draw when times were hard. A Women's Friendly Society, formed in 1837, met at the Wheatsheaf, and after only two months had between forty and fifty members. Other groups that held meetings at the Wheatsheaf included the Chartists in the 1840s, wrought cotton and worsted hosiery workers from three counties in 1849, framework knitters in 1850, and, of course, the Licensed Victuallers' Association met at the Wheatsheaf and other local pubs.

In 1863, the pub was available to let with immediate possession, and for a brief period, until 1874, the Wheatsheaf was known as the Robin Hood. The inn was equipped with every convenience for good trading, being situated in a populous neighbourhood, having an income of around £60–£70. However, by 1874 the Robin Hood had reverted to being known as the Wheatsheaf, although throughout this period the yard behind the establishment had continued to be known as Wheatsheaf Yard.

Structural alterations were made to the building in 1890, and the frontage has been rendered and painted. The window glass has been replaced, so the etchings which once associated the pub with the Offilers brewery are now gone. In 1998, the Wheatsheaf became part of the independent Orange Tree chain, which also owned Kelso's next door (now vacant), and Fenways on Baxter Gate, now Peter's Pizzas. In 2019, the Orange Tree closed, and after a period of refurbishment re-opened as the Jam Garden, a managed pub associated with the Wells & Co. brewery.

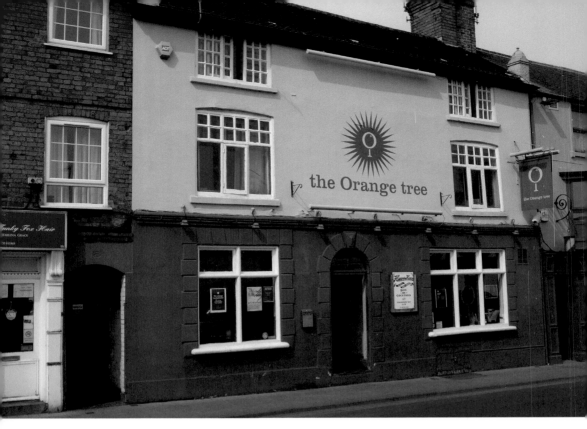

Above: Orange Tree, 2013.

Below: Jam Garden, 2021.

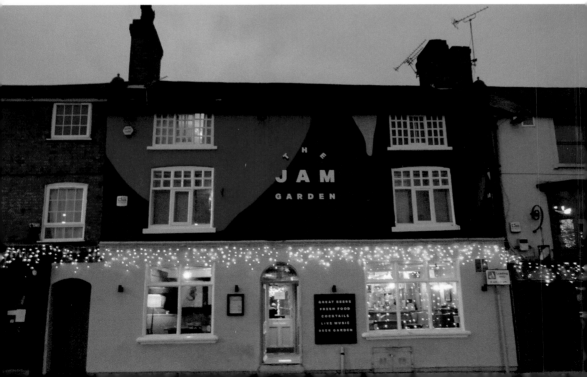

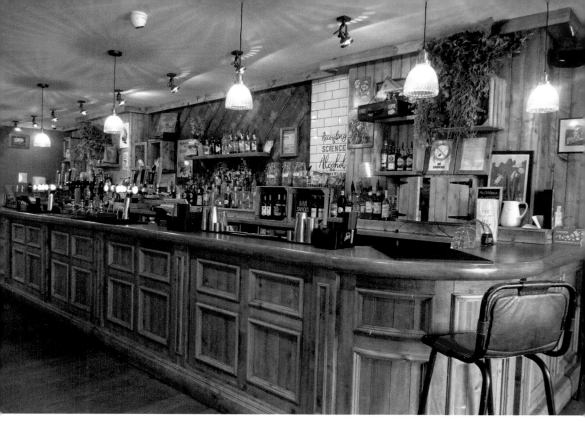

Above: Inside the Jam Garden, 2022.

Below: Garden at the Jam Garden, 2022.

9. Loughborough Arms, Baxter Gate

The Rose and Crown public house, Lot 64 in the Earl of Moira's sale of 1809, was described as 'a capital messuage with extensive front to Baxter Gate; a messuage adjoining, a blacksmith's shop and good yards, and garden'. By 1822 the licensee was Richard Dixon, and the pub's location on Baxter Gate made it an ideal place for a drop-off and pick-up point for the *Royal Dart*, a light post coach which travelled between Leicester and Nottingham. On Saturday mornings a coach also picked up here, bound for the Leicester market.

Like many local pubs in the nineteenth century, the Rose and Crown was a venue for auctions, and in 1852 was itself one of the properties being auctioned within, as landlord Harry Harridge moved to the Griffin. It was described as an old-established public house with extensive premises, which included a brewhouse, cellars, a large yard, stabling for eighteen horses, piggeries with lofts over, and other buildings.

Inquests were also held at the pub, like that into the accident that caused the death of John Arthur Goode on the railway. Local clubs and societies also held meetings and shows within; in 1863 a new lodge associated with the Independent Order of United Brothers, Leicester Unity, was opened at the Rose and Crown, when Mr Thomas Warner was licensee, and the second annual Celery Show took place at the pub in 1888. Traditional pub games have taken place here over the years, and the pub fielded its own skittles team, taking part in the Loughborough and District League.

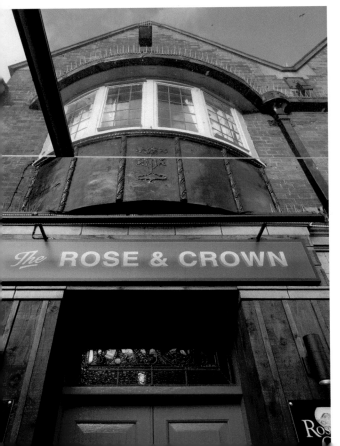

Rose and Crown, 2019.

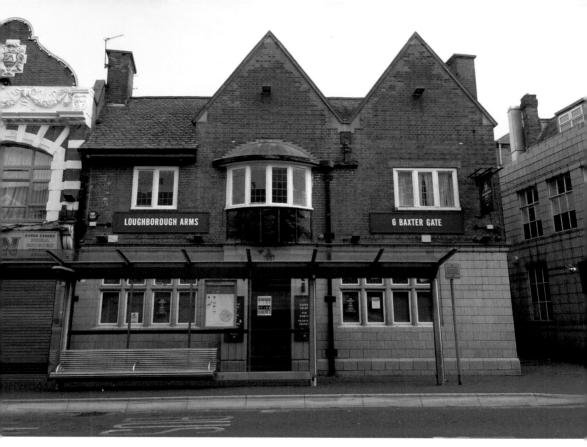

Loughborough Arms behind the bus shelter, 2021.

The position of the Rose and Crown on Baxter Gate was changed during the road widening works of the mid- to late 1920s. Until about 1924, Baxter Gate, like the other early streets of Loughborough, had been narrow, but the extensive programme of works changed the look and feel of the street, as old buildings were demolished and replaced with modern structures. The new pub has Dutch gables, a roof of local Swithland slate, stained-glass motifs in the ground-floor windows, and is clad in faience tiles from Hathernware. The pub also took on a new name, hence, by 1927, Mrs Jones was the licensee of the Loughborough Hotel, a name which endured for many years.

By 1978 the pub had reverted to its original name, and in 1981, the pavement at the junction of Baxter Gate and High Street was widened, thus narrowing the road slightly. Since the creation of The Rushes shopping centre and the demolition of the bus station off nearby Biggin Street in 2003–04, the pub has found itself in a bustling, redeveloped area of the town. It was added to the Borough Council's register of locally listed buildings in 2004. During the twenty-first century there began a period of rapid name changes: to Bar 21, Twentyone, the Bandwagon, and the Custard House in 2008, before a return to the Rose and Crown in 2018. In 2019, the pub was sold, and during the pandemic of 2020–22, the pub was again re-branded, taking the name the Loughborough Arms.

10. Moon & Bell, Ward's End

The Moon & Bell is in a former retail premises, whose upper floors had previously been home to Loughborough income tax office. The building, known as Atherstone House, replaced an earlier house of the same name, which was home to the Atherstone family, local dyers. The pub opened in March 1999 following a £750,000 refurbishment of the building, which took four months to complete.

The name Moon & Bell was created to reflect what George Orwell considered to be, in his 1946 essay 'The Moon under Water', the perfect pub. The essay, which appeared in the *Evening Standard*, outlined the ten criteria that Orwell's ideal pub would satisfy. This included that the venue would be quiet enough that you could hold a conversation, bar snacks would be available, as would other necessities (Orwell's list contained cigarettes, tobacco, aspirins, and stamps!), and drinks would be served in appropriate glasses – so no beer served in a handleless glass. So that's the moon bit – what of the bell part of the name? Well, this was included to reflect the pub's position – in Loughborough, which has long been known for its bell foundry.

In May 1999, shortly after its opening, the Moon & Bell took part in the town's four-day beer festival, bringing in lots of beers that weren't usually available in Loughborough. Ten years later, in 2009, the landlord created some of his own special

Moon & Bell, 2022.

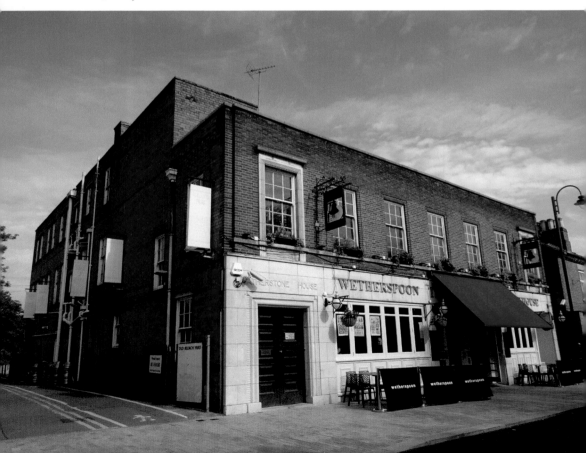

beers for the Six Nations Championships. In 2005, the pub was awarded the Cask Marque, and has been the Loughborough and North Leicestershire CAMRA Mild Pub of the Year in 2008 and 2009, and Pub of the Year in 2011, and has also been listed in the CAMRA *Good Beer Guide*. In November 2021, like the Amber Rooms, it was a winner in the Loo of the Year Awards, gaining a gold medal.

11. Needle & Pin, The Rushes

When the electronics shop on The Rushes closed its doors in 2008, those doors remained shut until a planning application that had been submitted to the Borough Council in mid-2015 was approved, and work began on creating a micropub. The Needle & Pin – whose name reflects the building's history, the new microbrewery, and the presence of a regularly used record player upstairs – has been awarded the Loughborough and North Leicestershire CAMRA branch Cider Pub of the Year award in 2016, and the branch Pub of the Year in 2018, as well as appearing in the CAMRA *Good Beer Guide*. The drinks on offer are many and varied, and include beers, like St Austell Trelawny, gin from the local Burleigh distillery, and whisky from Tomatin's French Collection.

The pub has been a venue for a wide variety of events, including performances as part of the annual Leicester Comedy Festival (not held during the pandemic, but

Needle & Pin, 2022.

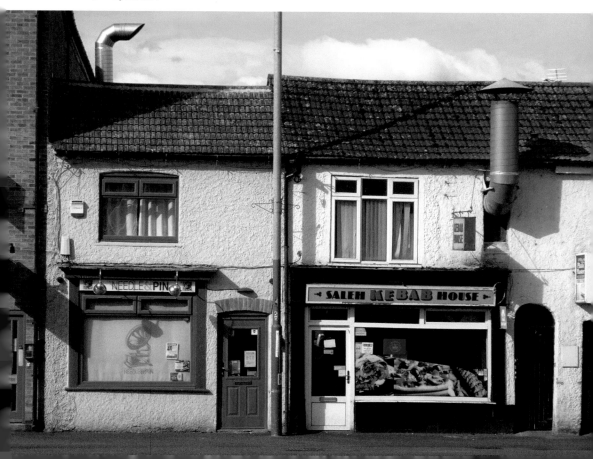

Needle & Pin record player, 2022.

returned in February 2022); poetry reading evenings; a meeting place for a craft club; and music performances, including folk, and music from the Hathern Band, who have also played at Charnwood Brewery.

During the pandemic, the Needle & Pin offered a delivery service to customers and maintained contact with people through weekly events on social media, like a quiz and bingo, and was recognised by the local CAMRA branch with a Special Award for Services to Customers during the pandemic. The owners also took advantage of the period of closure to do a spot of redecoration. Since re-opening, the venue has taken part in the pay-it-forward initiative, in which customers donate the cost of accessing the local community supermarket. In 2022, the Needle & Pin has introduced its own 200 Club and a loyalty card, as well as promoted Women's History Month and International Women's Day through celebrating the women who are involved in the brewing and spirits industry.

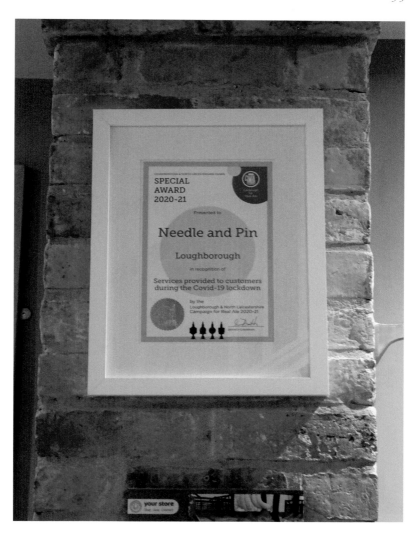

Needle &
Pin CAMRA
award, 2022.

12. Organ Grinder, Wood Gate

The Organ Grinder, part of the Blue Monkey Brewery chain of Nottingham, fronts onto Wood Gate, where between the second-floor windows the former name can easily be seen – the Old Pack Horse. The side and rear of the pub run along Pack Horse Lane, and it is on one of the buildings at the rear that a date is clearly visible, highlighted in dark bricks – 178? – the final digit lost or hidden behind a drainpipe! The pub was Lot 204 in the Earl of Moira's 1809 sale. Until around 1813, Pack Horse Lane was part of the main road from Leicester, and the re-routing along what is now the short stretch of Leicester Road from Barrow Street towards High Street resulted in the demolition and re-building of the Cross Keys (now the Phantom) whilst, according to Swift, this left 'the Pack Horse up a side street'.

Side street it may have been, but in the mid-twentieth century where there had previously been stables, horses, wagons and carriages, there was now a busy bus route,

with buses stopping here to collect and drop-off passengers, although in 1956 moves were afoot to continue the route from here down to The Rushes.

In the nineteenth century, many property and land auctions took place within the pub, and in 1834, possibly following the bankruptcy of Luke Gimson's lace manufactory in 1832, twist lace machines were auctioned. When John Wakefield took over the running of the pub from John Summerfield, in 1844 he auctioned off his own household furniture. Property belonging to Arthur Hatfield, a licensed victualler at one time at the Royal Oak, was auctioned at the Pack Horse in 1855 following Hatfield's death. The yard at the back of the Pack Horse was sometimes used for auctioning seasoned wood, and one such sale, in 1862, was so large it also spread across to the yard of the nearby Marquis Of Granby pub.

It is likely that some of the Luddites may have visited the pub before attacking John Heathcoat and John Boden's lacemaking factory in June 1816. In the 1820s and 1830s, annual carnation and gooseberry shows took place in the pub, before the latter moved to the Peacock in the 1860s. It was in the 1860s that the Pack Horse was the venue for meetings of the allotment holders who had plots on Mr Warner's land. A group of Liberals met at the Pack Horse, specifically to celebrate the wedding of Queen Victoria, and the Good Intent Lodge of Oddfellows met there regularly.

In 1986, a group of walkers recreating the Jarrow March on its 50th anniversary took their evening meal at the Pack Horse, rather than at the Town Hall as the marchers had before them. More recently, the pub has been the venue for performances: one notable

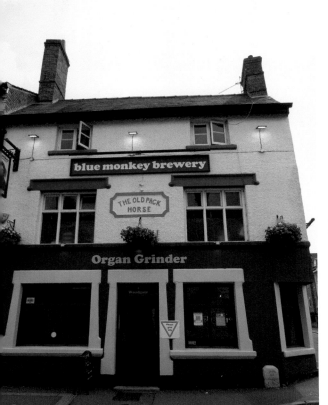

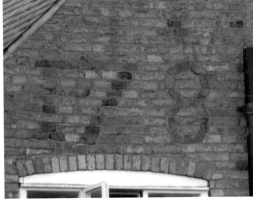

Above: Organ Grinder – possible construction date.

Left: Organ Grinder during the pandemic, 2021.

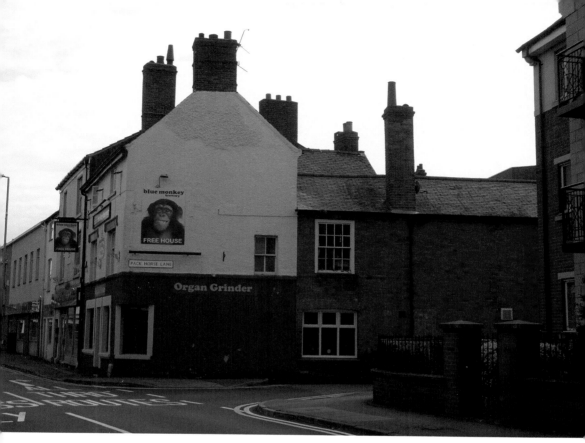

Organ Grinder on Wood Gate and Pack Horse Lane, 2022.

play focussed on Amos Sherriff, who led the Leicester unemployment march in 1905, and another told part of the story of the Zeppelin attack on Loughborough in 1916.

Darts, dominoes, and quizzes have played a part in the life of the pub, and in the 1940s, the Pack Horse darts players raised money to buy dartboards for men at war. Music events, particularly folk music, have also been an important feature of the pub, and in 1991, the Pack Horse Folk Club journeyed to Holmfirth, where they played at the thirteenth Dancing in the Streets Festival. As well as providing a space for local singers, the Pack Horse has hosted some familiar names from the folk music scene, including Martin Carthy, Dave Swarbrick, Johnny Coppin, and the local Sally Barker.

The Pack Horse was listed in the 1977 *Real Ale, Leicestershire & Rutland* CAMRA guide, and in 1991 hosted the Loughborough branch of CAMRA's Independent Beers Exhibition – a trade fair, open day, and exhibition of beers from independent breweries. Following its refurbishment in 1994, the Pack Horse advertised its offering, which included a pool room and a function room for hire, and in 2004 the building was added to the Borough Council's register of locally listed buildings. A further refurbishment followed in 2007, and in 2012 the building was renovated from top to bottom, and a stable bar introduced towards the rear of the building. During this renovation, an old copy of a *Leicester Mercury* was found when the fireplace was refitted, and possibly dated back to a previous renovation in 1966. Upon re-opening

in 2012, the Pack Horse was renamed the Organ Grinder. In 2019, the pub was the Loughborough and North Leicestershire branch of CAMRA's Pub of the Year, and was listed in the CAMRA *Good Beer Guide* for 2021.

13. Phantom, Leicester Road

Around 1745, the Cross Keys was a drop-off and pick-up point for the Ashbourne– Derby–Loughborough–Leicester stagecoach. A proposal to alter the route of the turnpike road, to eliminate a couple of nasty right angle turns, saw the three-storey building as described in the Earl of Moira's sale catalogue demolished and re-built around 1813. Nevertheless, numerous horse and cart accidents still happened outside the pub, and fines were regularly imposed on folk obstructing what were now quite narrow footpaths nearby.

Throughout the 1800s, auctions of land, buildings, farming and agricultural implements, and household belongings were held at the pub. In 1839, when the landlord of the Cross Keys left, the pub's furniture and fittings – ovens, stove grates, cupboards, brewing utensils, plate, linen, china, tables, glasses, chairs, carpets, oil cloths, bedsteads, feather beds, mattresses, and bedding, along with a malt mill – were auctioned on the premises. Available to let in 1855, the pub was described as having stabling and loose boxes for twenty-five horses, a very large yard, and every convenience needed to carry on an extensive trade, with a hack business attached,

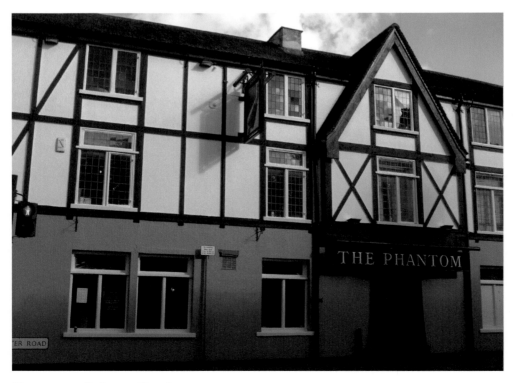

Phantom on Leicester Road, 2015.

and rent and incomings described as 'moderate'. An auction at the Cross Keys in 1862 included its own brewing vessels and fixtures, coppers, glass, china, feather and flock beds, bedsteads and other effects.

In February 1864, the pub itself – brewhouse, stabling, skittle alley and a large yard – was auctioned at the nearby Bull's Head, and available to let the following month. In June 1877, the Cross Keys was again auctioned, this time on its own premises, and was described as an area of 939 square yards with a frontage of 45.5 feet to Pinfold Gate and 142 feet to Leicester Road, with brewhouse, washhouse, outbuildings, carriage houses and stabling for thirty horses, and a substantial well-built dwelling house with large yard adjoining the 'hotel'.

In the mid-twentieth century, the yard was let to a variety of local businesses. In June 1994, following a period of closure for refurbishment costing £400,000, the Cross Keys re-opened as the Phantom and Firkin. Two bars had been knocked into one, some outside buildings had been demolished, the garage and store converted into a mini-brewery. In 2001, the pub name was shortened to the Phantom, and in March 2015, a £220,000 refurbishment gave the Phantom a new interior design, new signs, and covered areas outside.

There have been many activities in the pub and yard down the years. Several stud horses stopped off at the Cross Keys to conduct their business – Bacchus in 1810, Negociator in 1828, and Grey Prince, and Rector in 1862. Horse trotting races have

Outbuilding at the Phantom, 2022.

also centred on the Cross Keys: in 1821, the horse belonging to Mr Tyler of the White Lion pub raced from the Peacock on Belgrave Gate, Leicester, to Loughborough's Cross Keys, a race repeated in 1879, and in 1852 two ponies took part in a trotting match, from the Cross Keys to the tollgate on Leicester Road.

The Licensed Victuallers' Protection Society (later the Licensed Victuallers' Association) met within, and the United Ancient Order of Druids, Hand and Heart Lodge No. 116 held their anniversary dinner there. The Loughborough and District Fanciers' Society held a bird show for members at the Cross Keys, and members of the 46th North Midland Division, Mechanical Transport, 1914–18, had a gathering within.

In 1822, Pearson, a noted runner from Liverpool, ran 50 miles in eight hours around a quarter of a mile loop from the Cross Keys as a bet. In 1898, William Harris, 'the Spider', ran from Sileby to the Cross Keys, missing his target pace of 11 miles per hour by two minutes. In 1915, an exhibition game of billiards took place in Nottingham between Kelsall Prince (the Boy Champion of England) from the Cross Keys and H. Prince Jr of the Greyhound in Nottingham.

The Cross Keys came close to being accidentally burned down several times. In 1843, smouldering wicks from candles in the cellars ignited the joists, but luckily the fire was caught before much damage could be done, and in 1846 a gas explosion in a nearby straw bonnet maker's shop narrowly missed the pub. In 1937, there was a serious explosion and fire at the pub, but thanks to the continual barking of the landlord's dog, Flossie, who alerted him to the danger, only a store shed was demolished, with other buildings suffering fire damage.

Today, the Phantom, so named because it is believed to be haunted, has re-opened following closure due to the pandemic.

Phantom, 2022.

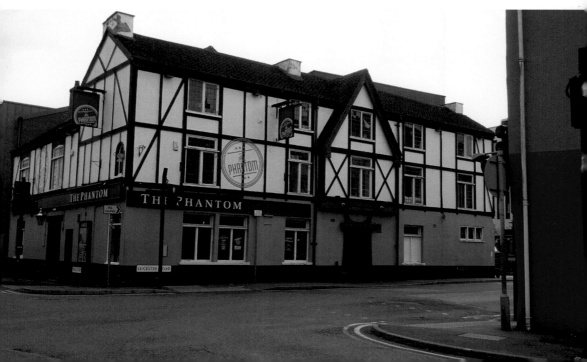

14. Project, Market Street

Project is a relatively new name for a relatively new pub! Positioned on Market Street, in between Cask Bah and the Griffin pub, the premises, constructed around 1998, forms part of a block of retail units. The modern, red-brick, low-rise building, along with those adjacent to the walkway, replaced a taller, more imposing old edifice, which had once been Wright's Mill. Prior to this, it had been the lace-making factory of John Heathcoat and John Boden, which had been attacked by Luddites in 1816. Heathcoat is remembered in the green plaque on the retail premises on the opposite side of the walkway, and in the nearby Heathcoat Street, and Boden in John Boden Way.

Originally, the pub was opened as the Warehouse café and bar in November 1998, and was granted a licence to play music until 1 a.m. in May 1999. In 2002, the bar was renamed Barracuda, and was one of three Barracuda Bars developed in the UK that year, in a chain of 150 such bars. In 2003, the bar was the subject of a refurbishment costing £100,000, and in 2007, the bar was re-branded as Varsity, owned by the Varsity Leisure Group. By 2015, Varsity was owned by the Stonegate Pub Company, as, at the time, were two other town pubs, the Phantom and the Unicorn, now Champs.

In August 2015, the pub again changed hands, and became known as Wild Lime. This establishment closed just before Christmas in 2017, and in March 2019 it was

Wild Lime, 2016.

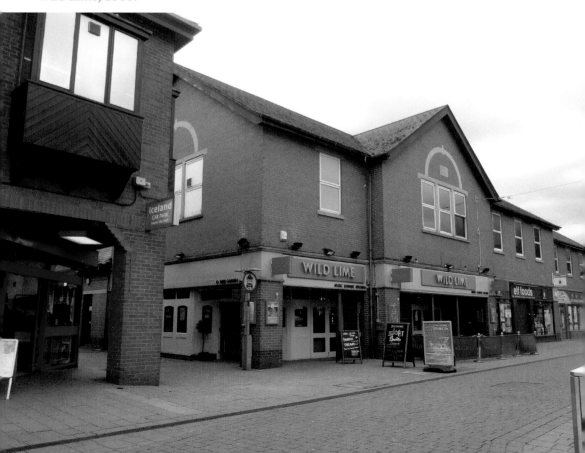

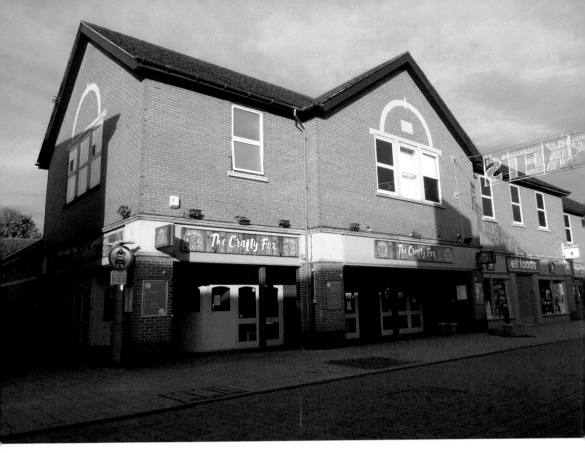

Crafty Fox, 2021.

announced that the pub would become the Crafty Fox, the lease being signed for fifteen years. The Crafty Fox was opened in April 2019, and had a strong focus on food, sports, and party catering, which would appeal to both students and locals.

Unlike the older pubs in town, this newer pub has not been the venue for inquests nor auctions, as there are now specialist venues for such events. During its time as Wild Lime, the establishment played host to a number of celebrity visitors, including Steve McFadden, an actor in the popular soap *Eastenders*, and reality television star Gary Beadle.

As well as plenty of seating indoors, today the pub has an outside seating area to its frontage on Market Street, which in view of the coronavirus pandemic of 2020–22 has proved to be very popular. In early 2022, Crafty Fox became Project.

15. Swan-in-the-Rushes, The Rushes

In the summer of 1863, the Old Plough in The Rushes, where good trade was bringing in an income of about £40, was available to let, and in October of the same year the household furniture, brewing vessels, fixtures, and other effects were auctioned off. The timing of these events coincides roughly with the winding down of activities at the Plough Inn in Market Place, before the building changed use, leaving only the Plough on The Rushes. In 1883, the name of The Rushes premises was changed to the Charnwood Forest Railway Inn – not to be confused with the pub of the same name on Navigation

Street, Shepshed, now the Top Railway. The inn was licensed to let horses, carriages, and wagons, and a two-horse brake would leave the premises every Sunday at 2 p.m. bound for the Charnwood Forest, tickets being 2s for the return journey.

In June 1888, the Charnwood Forest Railway Inn, listed as a beerhouse in The Rushes, was up for auction at the King's Head. It was described as having a coach house, a large club room which was being used as a music hall, a storehouse, cottage, piggeries, stabling for six horses, a yard, a skittle alley, a quoits ground, and adjoining buildings. Although the bidding started at £500, it stopped at £1,120, and despite the low annual rent of £45 the property did not reach its reserve price, so remained unsold ... until the next auction! This took place the following May, at the same place and included all the same buildings, but was now also offering a barber's shop. Rent was still a low £45, and the premises would be available for occupation from 29 September. Robert Astle, the new landlord, duly applied for a renewal of the licence, and after some discussion about the entrance to the music room at the back being insufficient, the licence was granted.

By 1905, the inn was described as a lodging house, being one of three along Swan Street, which included the Rising Sun and the Rising Star, all places offering very short-term lodgings and respite for travellers and people down on their luck. At the licensing session in March 1930, it was stated that although there had been no complaints about the inn for thirty years, there was some concern that the building was inferior to other neighbouring pubs. Thus, in 1931–32, a new building appears to have been constructed, and the name of the pub changed to The Charnwood Inn. At the same time, the last of the lodging houses, the Rising Sun, and adjoining properties were scheduled for demolition, to be replaced with shops. In 1986, the pub was again renamed, to become the familiar sign we see today.

The pub has long been a meeting place for a variety of groups: in 1866 the *Loughborough Monitor* reported on the creation at the venue of a 'new Lodge of the Ancient Order of Shepherds in connection with the Ancient Order of Foresters', an organisation similar in name to that proposed by Thomas Glover of the White Horse (now a restaurant) in 1844. Later, the pub was the meeting place for the Socialist Forum, the Loughborough Ladies' Speakers' Club, Charnwood Action for Real Democracy, and the Labour History Group. The pub has been visited by the likes of Dusty Hare and Isla St Clair, its Swan Folk Club has hosted performances from the likes of Sally Barker, and various theatre groups have performed social and local history plays on the premises. Games played within have included cribbage and darts, quizzes have often been held, and the venue has hosted events associated with the Leicester Comedy Festival.

The Swan-in-the-Rushes has taken part in Christmas campaigns to deter drinkers from driving, particularly by selling reduced price soft drinks during the festive period. It has hosted a CAMRA Real Ale Exhibition and has been awarded numerous CAMRA Loughborough and North Leicestershire branch awards, like Town Pub of the Year (2006), Cider Pub of the Year (2019, 2020, 2021, and 2022), and appears in the CAMRA *Good Beer Guide*.

Upon re-opening in October 2021, the venue described its offering as having a traditional two-room layout with spacious beer garden, a room for playing darts or board games, and a multi-purpose room upstairs.

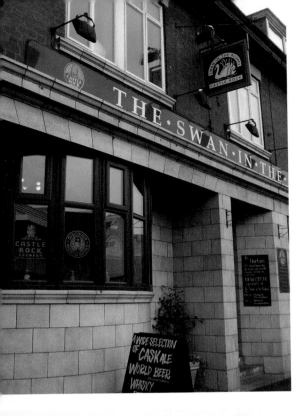

Left: Swan-in-the-Rushes, 2015.

Below: Swan-in-the-Rushes, 2022.

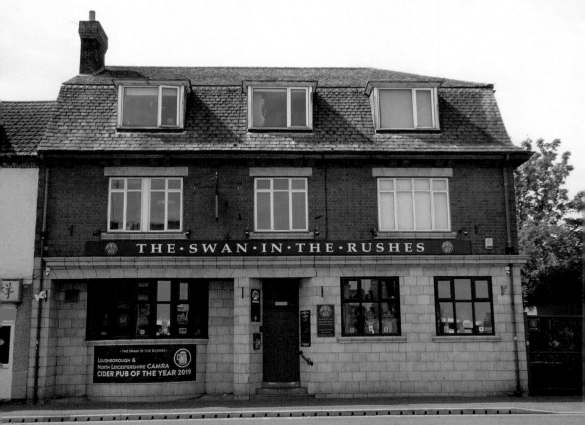

Above: Entrance to the Swan-in-the-Rushes, 2022.

Right: Inside the Swan-in-the-Rushes, 2022.

16. Tap & Clapper, The Rushes

Loughborough sits in the Soar Valley, and the Tap & Clapper is situated in The Rushes, in the lower part of the town. The rainstorm – with thunderclaps, perhaps – of July 1853 had disastrous consequences when the Wood Brook, which passes close to what was then the Black Lion, reached about 6 feet above its normal level, leaving a trail of destruction in its wake, and the whole of The Rushes from the Black Lion to the Ram pub (now a dry cleaners), like a lake.

In 1855, the Black Lion was up for auction at the Plough in Market Place, and was described as being on the corner of The Rushes and Green Close Lane with a large yard, a brewhouse, stabling, and with some useful outbuildings. Like many others of the older establishments in Loughborough, the Black Lion was also a venue for inquests and a meeting place for various groups, which included the Licensed Victuallers' Association. Also in common with other pubs, the Black Lion fielded a pool team, played in the local darts and football leagues, hosted fundraising events, and promoted soft drinks in the festive season.

In March 1990, the Ind Coope Brewery closed the doors of the Black Lion, and in May 1991, the extended and refurbished pub opened under the watch of the Hoskins Brewery. Another makeover in 1998 was accompanied by a name change to the Hobgoblin, still part of the Hoskins Brewery, but becoming part of its Wychwood Brewery chain. During a further refurbishment in 2014, John Taylor and Co., the local bellfounders, created a bar bell for the pub which was renamed the Tap & Clapper, and bell clappers form part of the interior decoration of the pub.

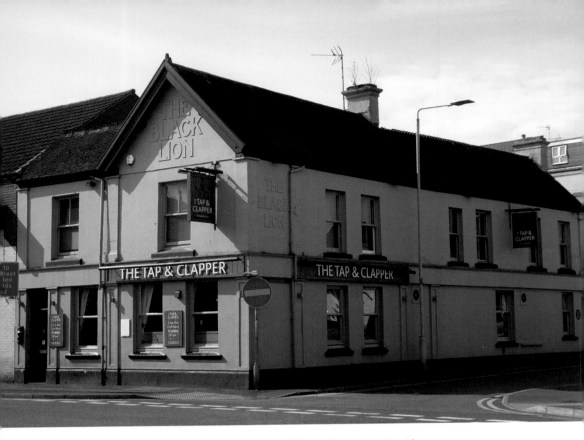

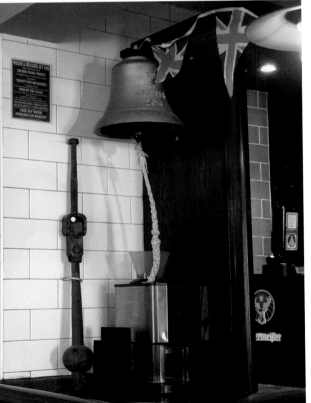

Above: Tap & Clapper, 2022.

Left: Locally made bell and clapper inside the Tap & Clapper, 2022.

Throughout its refurbishments and renaming, the original name of the pub remains clearly to be seen on the upper storey of the building, on both the frontage onto The Rushes and the side of the building on Green Close Lane.

Following the pandemic, the Tap & Clapper re-opened in May 2021, and today it screens many sporting events, from football to rugby to tennis, and hosts music events, including the popular karaoke nights.

17. Three Nuns, Church Gate

According to Wells, the pub that we know today as the Three Nuns was opened pre-1666 as the Three Nuns. However, over time, this pub has had different names, and as Lot 251 in the Earl of Moira's sale of 1809, it was known as the Three Tuns, a name which endured through the time of landlords William Bentley (1819–1844), William Adkin, and John Henson. In 1864, when the licence was transferred from Henson to Harry Harridge, who had come from the Griffin, the pub name changed again, this time to The Eagle Inn.

The new name endured through the time of landlords James Lord, William Webster, Charles Fisher, John Henry Walker, and Frank Sykes. In 1935, when Mrs Annie Sykes applied to transfer the licence to Mrs Gent, there was no danger of another name change, but rather a danger the pub might close altogether, as the brewers, James Eadie Ltd, proposed to transfer the licence of the Eagle Inn to an expected new pub on the recently built Holt estate. Luckily, the transfer was not needed as the proposal to build the pub was turned down. The new pub would, however, later be built on the corner of Holt Drive and Forest Road, and be called the Forest Gate, now the Toby Carvery.

And so, the licence for The Eagle transferred instead to Mrs Gent, and during her time at the pub the premises were used as the location for the sale of various animals, ranging from goats, through ponies, to puppies! After several more licence transfers, by April 1958, The Eagle had been renamed the Three Nuns and was part of the Everards family. An advert in the *Leicester Chronicle* in April 1958 invited readers to try the Three Nuns and prove to themselves that an Everards Inn was different – on top of the excellent beer, the good company, and the pleasant surroundings, an Everards Inn offered a place to entertain relatives and friends, and it was the atmosphere that made an Everards Inn different!

In its early days as the Three Tuns, and as The Eagle, the pub was a venue for inquests into deaths and for auctions. More recently, the Three Nuns took part in BBC Radio Leicester's Christmas sing-along events, and in 1996 contributed to the repair and renovation fund for the nearby church of All Saints with Holy Trinity (known as the parish church). The pub itself was refurbished in 2012, and in celebration of its transformation, Everards brewed a special ale – the Three Nuns Ale. Darts and other traditional pub games were played at the pub, and a football team fielded in the Everards Charnwood Sunday League.

Live music was also a feature of the pub's offering, mostly local bands, but in 2015, Gary Barlow turned up at the pub and sang as a surprise for one of his top fans on her wedding day. Friends who had arranged this had known for about nine months that he was coming, but had managed to keep it a secret, even from the pub staff who only

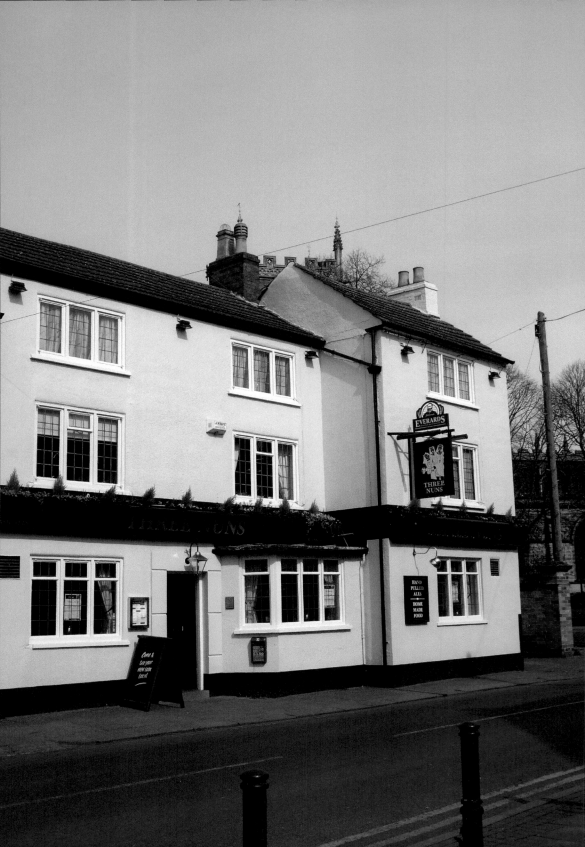

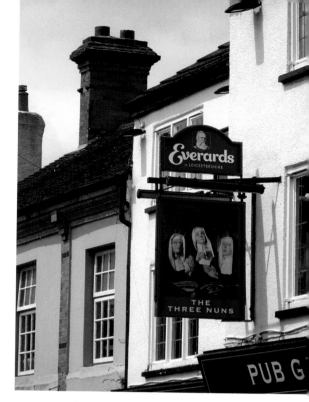

Opposite: Three Nuns, 2013.

Right: Three Nuns, 2021.

Below: Three Nuns with White Hart to the left, 2022.

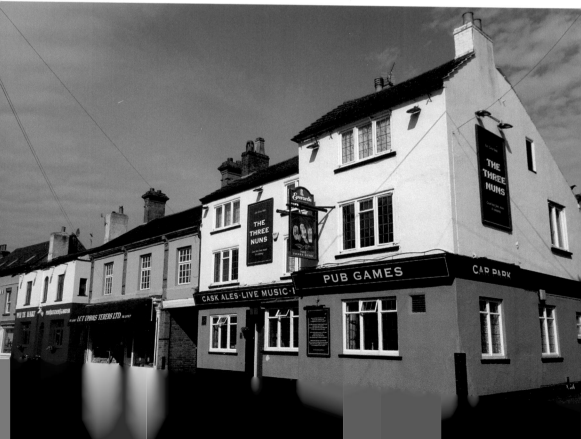

found out three weeks before the event! Since re-opening following the pandemic, the Three Nuns has continued to offer a programme of varied live music.

18. Wheeltapper, Wood Gate

Before opening as the Wheeltapper, the space beneath the student accommodation known as the Print House was a café-bar called the Printroom. It was described as a modern, tasteful venue with a Continental café vibe and extensive food menu, and somewhere fundraising events could be held. In 2008, a pamper evening was held in conjunction with a cosmetics company to raise money for Rainbows, the local children's hospice.

Fast forward ten years, and the space has transformed into the Wheeltappers Cask and Tap House, where the venue's interior theme matches its name! As a nod to Loughborough's involvement in the railways, the tap house is named after the workers who used to check train wheels for damage and cracks, by hitting them with a long-handled hammer, and checking that the axle boxes weren't overheating. Inside are reproductions of those iconic 1930s railway posters, British Railways and intercity signs, and beer pumps set into wooden casing that have echoes of points in signal boxes.

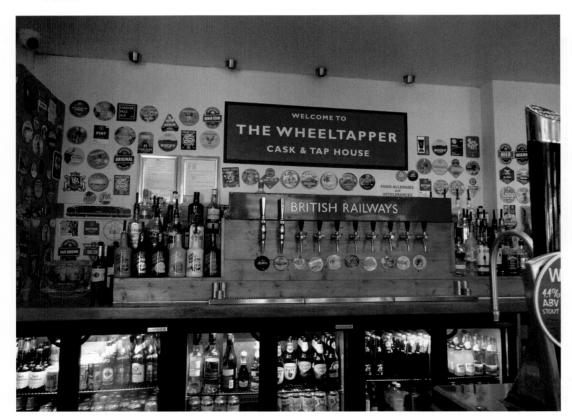

Inside the Wheeltapper, 2022.

Right: Steam engine darts at the Wheeltapper, 2022.

Below: Host John Davis at the Wheeltapper, 2022.

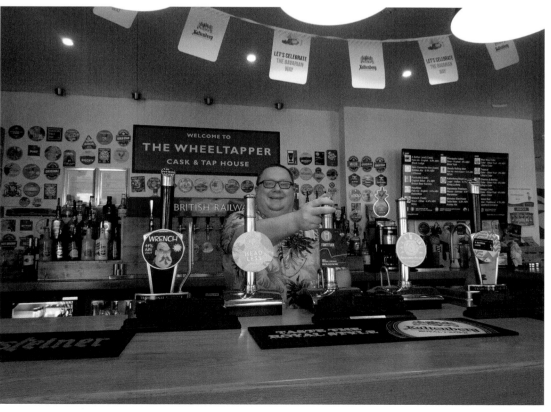

Although a relative newcomer when the pandemic of 2020 began, the Wheeltapper adapted, re-opened for a period during the summer of 2020, and offered free local delivery. In mid-2021 a loyalty card was introduced, and in July the venue took part in the Great British Beer Festival At Your Local. In November 2021, after serving customers in the garden, the pub was able to fully open and welcome people indoors. Over a period of four days in March 2022, the venue held their second gluten-free beer festival in association with Beers4Coeliacs, and has welcomed back live music performances. The drinks offer is regularly changing and includes the likes of Egyptian Cream Stout from Nene Valley Brewery, and Hufflepuff bitter from Little Ox Brew Co. in Whitney, along with a variety of ciders, like Devon Red, and lagers from Austria and Germany.

19. White Hart, Church Gate

The White Hart public house, Lot 72 in the Earl of Moira's sale in 1809, was described as a pub building with good frontage and gateway, in the occupation of Samuel Stevenson. Along with the pub, two tenements in the yard, the brewhouse, outbuildings, yard and garden were also included in the Lot. The White Hart was again up for auction, at the King's Head Hotel, in 1863, this time in the occupation of Edward Brown, a baker and maltster, and his wife, Jane, who was the beerhouse keeper. The pub had a yard, gardens and outbuildings, and also included in the sale were two cottages at the back of the White Hart Inn. Following the auction, the building was altered and improved, and new houses and shops were built around it in 1866.

Like many pub names in Loughborough, the name associated with this longstanding pub was significant and known across the country, as the white hart was a representation of the badge of King Richard II. In 1980, the pub name was changed to the Glenavon, but this lasted only a few years, when in 1989 the venue underwent a refurbishment and reverted to its original name. A further, extensive refurbishment was completed in 2013, after which the White Hart, previously associated with the Ansells brewery, opened as a freehouse. In 2019, a dramatic colour scheme was applied to the exterior of the pub.

Perhaps because of its proximity to the Three Nuns and the Windmill, the White Hart does not seem to have been a regular meeting place for many groups or societies, although one group that did meet here after the end of the First World War was the Old Comrades. They were perhaps encouraged by landlord Charles Sewards, whose pub was one of those that had contributed to the 1916 Christmas parcels fund run by the local newspaper to send gifts to local men on active service, and perhaps as he had lost his son-in-law in the conflict in 1917.

There have only been a few occasions when the annual travelling fair, which was granted its charter in 1221, has been unable to come to town. One of these was during the pandemic of 2020, another in 1915, during the First World War, when Mr Sewards, who was on the committee of the Soar Angling Club, proposed a fishing match be held instead. Earlier in the year he had organised a successful match, which took place near Normanton-on-Soar, and which saw eighty-one people compete for prizes that were distributed at the White Hart.

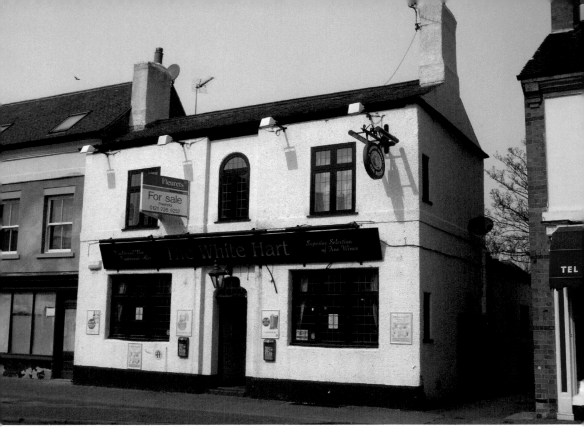

Above: White Hart for sale in 2013.

Below: White Hart with Three Nuns to the right, 2022.

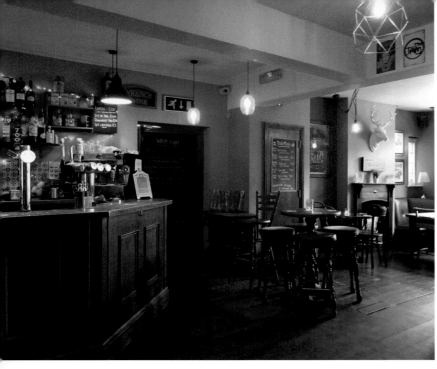

Left: Inside the White Hart, 2022.

Below: Garden at the White Hart, 2022.

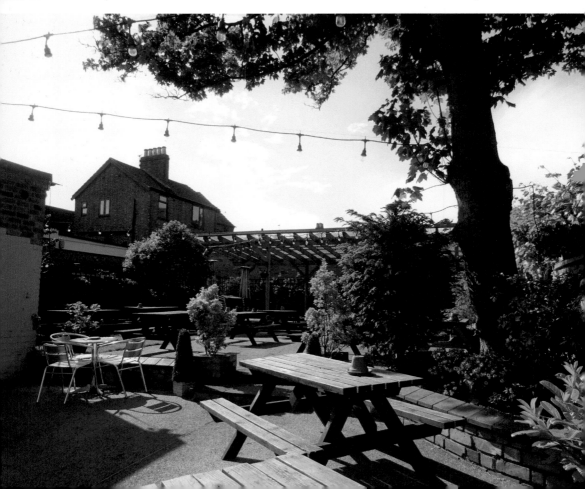

As well as angling, the White Hart has taken part in darts leagues, like the Strettons league, and the Royal Air Forces Association Battle of Britain cup, and had teams in the local pool and whist leagues. In 2016 and 2017, the White Hart won the Pub of the Year award of the Loughborough and North Leicestershire branch of CAMRA, and in 2021 appeared in the CAMRA *Good Beer Guide*.

20. Windmill, Sparrow Hill

Emblazoned across the front of the Windmill are the words: 'The oldest pub in Loughborough'. Situated in what used to be the medieval town centre, and close to the former Guildhall and the former Manor House, both tree-ring dated to around 1455, it would seem likely that this is indeed a very old building.

The Windmill was sold in the Earl of Moira's sale of 1809, as Lot 76, and included stables, a brewhouse, outbuildings, yards, and a garden, along with the three adjacent tenements. The Cleever family were associated with the Windmill from this time until 1867 when the pub was auctioned on its own premises, and occupation passed from Christopher Cleever to John Speed. The premises was described as fronting Sparrow Hill, with a large yard, a garden, excellent cellerage, stabling for upwards of thirty horses, a brewhouse, a large club room, workshops, granaries and other outbuildings. The second Lot in this sale were the same three buildings as had appeared in the previous sale, but were described as tenements with a shop and bakehouse, also with a yard, outbuildings and other buildings, all with an extensive frontage onto Sparrow Hill.

In 1891, the Windmill was again up for auction, this time as part of the sale of the pubs associated with the Green and Hacker, Whissendine Brewery of Rutland. At the time, the brewery had eighteen pubs, many in Leicestershire, those in Loughborough included the Old Oak, the Talbot, the Black Lion (now the Tap & Clapper), and the Cooper's Arms.

Window detail at the Windmill Inn, 2021.

Although an application to lower the kerb outside the pub was refused in 1861, alterations to the building itself were undertaken in 1898, as a condition of the licence, and again in 1939, for the same reason. In 1976, the Windmill was listed in *Nicholson's Real Ale Guide to the Waterways*, in which it was described as an 'unspoilt house, well worth a visit', and the following year it was listed in the *Real Ale, Leicestershire & Rutland* CAMRA guide. In 1984, the Windmill was added to the national register of listed buildings and given Grade II status. In 1988, landlady Doreen Heath, whose parents Jack and Jane Hewitt had run the Talbot pub, opened the twelfth annual CAMRA Beer Festival in the Town Hall, just a short time before she retired after nearly twenty-eight years as the landlady.

As to be expected of a pub of this age, there have been many land and property auctions, and auctions of items like twist net machines held within, as well as numerous inquests into deaths in the area, including that of a forty-five-year-old man who died in Whirley Hole on the nearby meadows. Groups like the Odd Fellows opened a new lodge at the Windmill in 1834 and held regular meetings here, as did the Hand and Heart Lodge, No. 116 of the United Ancient Order of Druids. After the end of the First World War, the Old Comrades met at the Windmill, as well as at the nearby White Hart, and the Royal Antediluvian Order of Buffaloes (RAOB), Percy Gale

Windmill, 2017.

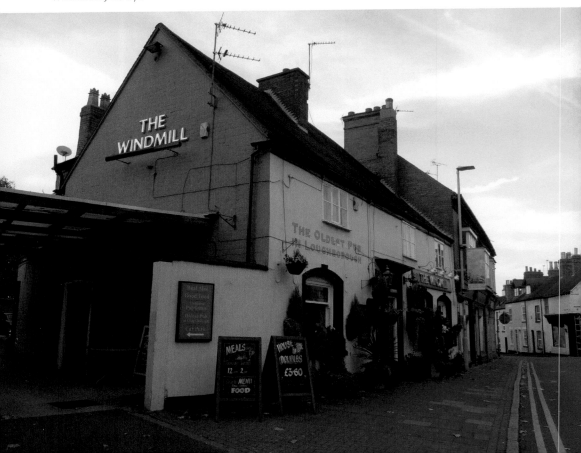

Lodge 944, were still meeting and fundraising here at the end of the twentieth century. A rather more unique fundraising group also met at the Windmill from 1930 to 1962, and from 1989 to more recent times: the Buttonhole Club raised money through those members not wearing a buttonhole contributing money to a fund. Latterly, money was raised for local organisations like Rainbows and Ashmount School in other ways, especially through a weekly raffle, for which in the 1990s the RAOB provided the prizes. Other fundraising at the Windmill has seen sponsored walks and an exercise bike marathon.

Sport has been associated with the pub for many years. In the 1930s, the Windmill took part in the local table skittles league, and in 1966 the pub started a football team, with landlady Doreen taking the position of President of the Charnwood Sunday League. The pub has fielded darts teams and taken part in the local quiz league. Leicester Morris men have performed at the Windmill, and very recently the local singing group the Shantyfolk have brought sea shanties to the town pub.

During the period of lockdown, the interior of the building underwent renovation, which revealed its quarry tiled floor, and the outside space, which runs alongside the Fearon Jitty (a footpath created in 1888 to link to the developing area around Toothill Road) was opened up.

Fearon Jitty left of the Windmill, 2022.

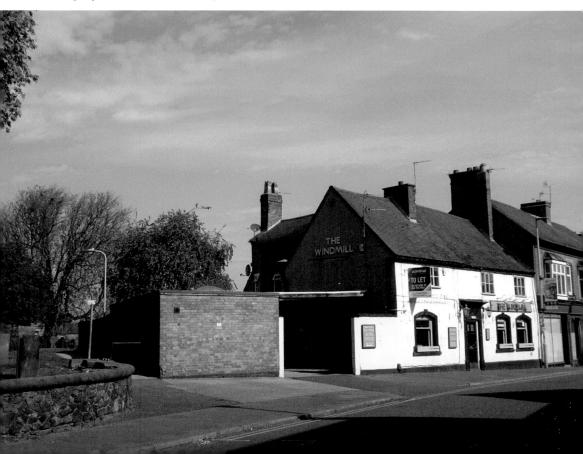

2

Pubs beyond the Town Centre

21. Beacon Inn, Beacon Road

In the early to mid-twentieth century, the area of Loughborough stretching from the town centre, along Forest Road and Beacon Road, heading towards Nanpantan and the Charnwood Forest, grew very quickly, with many houses being built on what is now referred to as the 'forest-side'. To support this burgeoning population, several pubs were established in the area, including The Beacon.

Beacon, 2020.

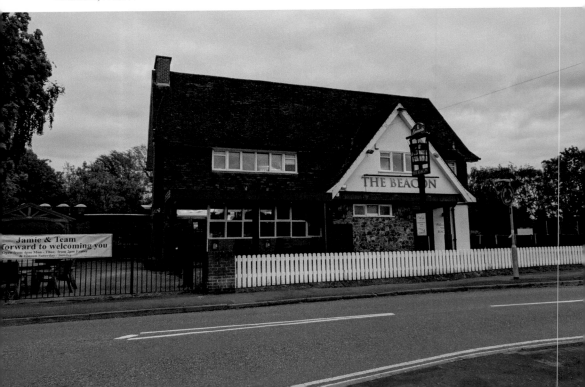

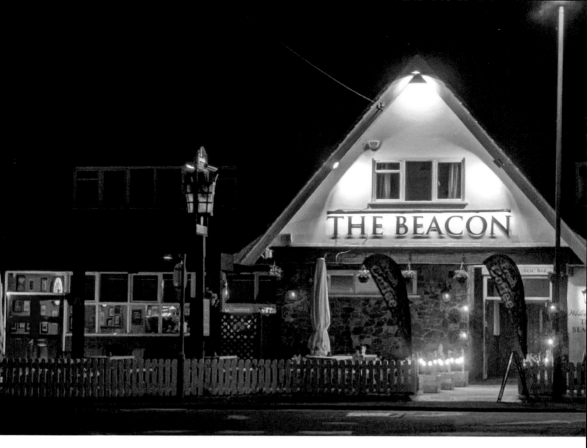

Beacon, 2021.

The site for the new pub had been purchased in 1962, and on 4 December 1963, The Beacon opened its doors. Architects from Long Eaton designed the pub and builders from Kegworth constructed it, but the bricks were supplied by Tuckers, masonry work had been completed by Collin Bros, and the roof tiled by Palfreymans – all Loughborough companies. The end result was a state-of-the-art premises of attractive design which complemented the surrounding properties. The building was centrally heated and air conditioned, and in addition to the public areas downstairs, a separate flat with private entrance was provided for the licensee. Inside, the pub had been fitted with a telephone for the convenience of the patrons, and outside there was a spacious car park, a lawn and paved terrace area, and a garden shelter.

At the time of opening, the manager was Mr W. Axe, and the pub was tied to Home Ales, which had had its headquarters in Daybrook, Nottinghamshire, since around 1890. The Beacon was the forty-fifth new house the brewery had opened since the Second World War, and the second in Loughborough, the first being the Ring O' Bells, which opened in 1956. The licence for The Beacon had been transferred from the Stag and Pheasant pub on Nottingham Road, which then closed for business.

Since its opening in 1963, The Beacon has remained a popular venue with its community, and has seen its regulars get involved in a variety of activities. In 1996, when boxers Frank Bruno and Mike Tyson fought a bout, sixteen regulars from

The Beacon were among the 5,000 Britons who went to the US to watch the match. In 2009, the pub regulars sent over 300 shoe boxes of Christmas gifts to soldiers in Afghanistan, and in 2014, the pub sold tickets to a charity barn dance held on the university campus in honour of one of the pub's regulars, a soldier who had suffered injuries in Afghanistan and had recently died. Other local fundraising events included a family evening and virtual run at the pub, arranged by a customer who raised money for Wishes4Kids by themselves running on 365 consecutive days.

The Beacon had an indoor skittles alley, which was typical of the Leicestershire type. By 2012 the pub was connected with the Everards Brewery and had darts and pool teams, as well as having a pétanque piste. Also in 2012, the pub took part in the Loughborough In Bloom competition and achieved a bronze award. In 2019, after a period of closure for refurbishment, the pub provided the Loughborough United football club with a new playing strip.

During the pandemic of 2020–22, The Beacon was closed for a time, during which it was renovated, and re-opened on 19 July 2021 under new management, and its extended offering now includes breakfast and coffee.

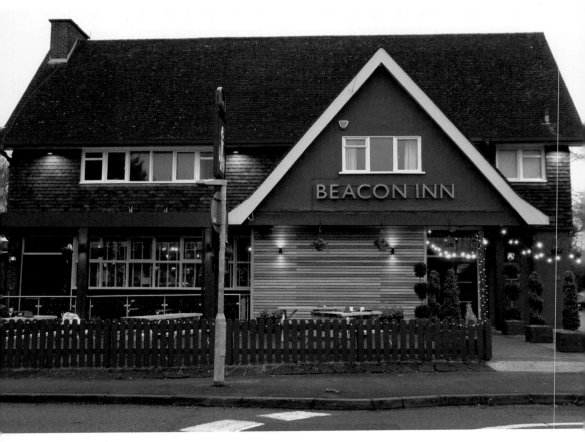

Beacon, 2022.

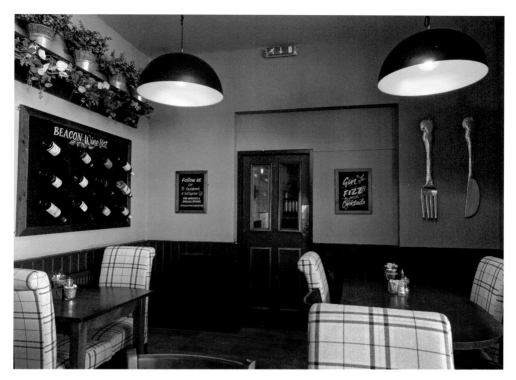

Inside the Beacon, 2022.

22. Boat Inn, Meadow Lane

Sitting alongside the Grand Union Canal, on Schwäbisch Hall Way, just after Meadow Lane Bridge No. 39, the Boat Inn now finds itself alone in serving the users of the town's waterways. The nearby Albion recently ceased trading as a pub, the Duke of York has long been demolished, and the Victoria has not been a pub since before Swift was writing in 1976. Swift also observes that the Boat was not as old as the Albion. This is possibly because the canalisation of the River Soar at Loughborough was completed by 1780, whereas the Leicester Navigation to Sileby didn't open until late 1793.

In 1859, the landlord of the Boat was a Mr Whittle, who, along with Mr Diggle of the Green Man (which is still intact, but inaccessible beneath the Carillon Court shopping centre), was responsible for organising a boat trip from Loughborough to Red Hill, near Thrumpton. Pick-up points were at Loughborough Wharf, Zouch, and Kegworth, and the respective fares were 1s, 9d, and 6d. In subsequent years, Mr Diggle of the Blue Boar (now demolished) in The Rushes arranged the trip.

Like many other pubs in the nineteenth century, the Boat was a venue for land and property auctions, and at one such in August 1863 the pub itself was for sale. It was described as being situated on the side of the Leicester Canal, and comprised a brewhouse, stables, a hovel, piggeries, and other outbuildings, as well as a garden and grounds at the back, with fruit trees and a summer house. The landlady at the time was

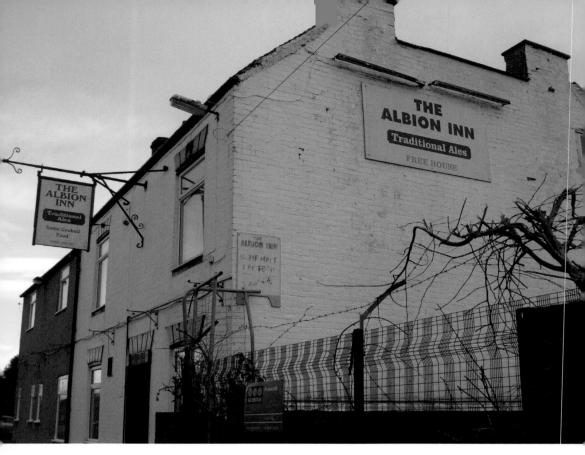

Above: Former canal-side Albion Inn, 2015.

Below: Anglers near Bridge 39 and the Boat, 2022.

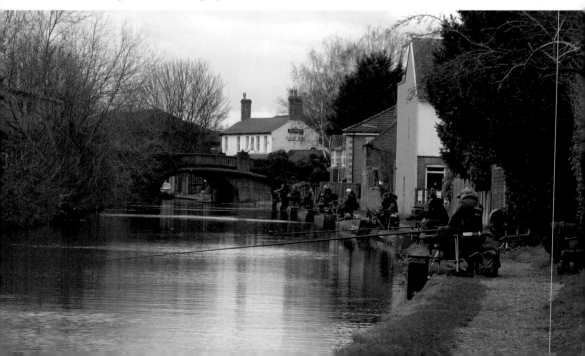

Mrs Graves. Only eleven years later, the pub was again up for auction, but this time at the Saracen's Head, now the Bell Foundry, at which the pub and two cottages were sold for £550, a price which apparently considerably exceeded the expectations of interested parties.

Being as it is situated on the towpath, the pub has regularly been the venue for the draws for the Loughborough Soar Angling Society competitions. Many anglers have taken part and have fished near the pub, and many presentation events have taken place within. Other sports have also been popular, and the Boat has fielded quiz teams, participated in darts competitions, and been visited by England footballer Peter Shilton, who accepted a cheque on behalf of the Arthrogyprosis Group, collected through a fundraising event.

In 1990, the pub underwent a huge refurbishment and gained a large new frontage whilst retaining its character as a traditional pub, serving drinks, and offering traditional pub games like darts and dominoes.

The year 1997 saw the inaugural Loughborough Canal and Boat Festival, which took place along the length of the canal, from the Boat to the Albion, with stalls along the towpath, model boats in the basin, and short boat trips running from the Albion to the Boat. There was also a traction engine and street organ, dancing, and face painting.

Canal-side Boat, 2022.

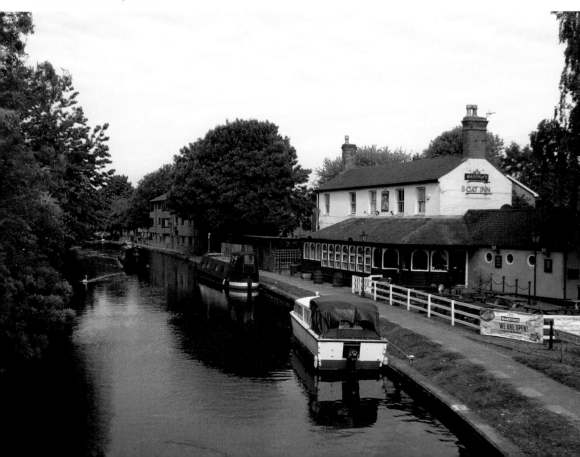

Other events that have taken place around the Boat include musical plays performed by Mikron, a canal-travelling theatre company who celebrated their 50th anniversary in 2022, and Morris dancing performed by local group Bare Bones, who hired two narrowboats and travelled to venues along the canal. Fundraising events nearby have included a pub crawl starting from the Boat, and a Mexican food evening inside.

The award-winning pub has been a finalist in the Union Pub Company Awards several times, has won the Most Responsible Retailer category at the Responsible Drinks Retailing ceremony, and has been awarded the Cask Marque. The Boat has also been included in Nicholson's *Guide to the Waterways*, and in the 1977 CAMRA guide *Real Ale, Leicestershire & Rutland*. Following a period of closure during the pandemic, the Boat re-opened fully on 12 April 2021.

23. Charnwood Brewery, Jubilee Drive

What better place to establish a small brewery than in an industrial unit previously used to produce cheese with a ready-made drainage channel down the middle of the floor?! Established in 2014, the Charnwood Brewery is situated in one such industrial unit, and stands out with its matt grey frontage, clear white signage, and a fabulous moving fox painted on the sliding entrance doors.

The enterprise was created by a local family, and the ethos is to stay local, stay small, and brew the best product that resonates with the locals. As such, beers are

Fox left: closed. Fox right: open! 2020.

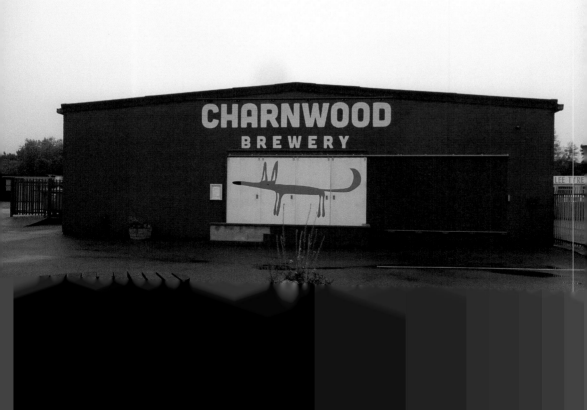

appropriately named to appeal to people in the area, and the offering has included Blue Fox, Vixen, Rainbow Fox, Over the Rainbow, and Steam Train, hinting at a nearby football team, a local children's hospice, and a unique double-track heritage steam railway!

Until the pandemic hit the brewery also had a bar area, which could host a small number of on-site drinkers, with a glass window allowing a view into part of the brewing space. Expansion has included opening a micropub in Mountsorrel and in Shepshed. Beers are supplied to all manner of local shops and restaurants, as well as being available at local events.

Very soon after production started, in October 2015, the American Pale Ale was awarded Silver in the Society of Independent Brewers (SIBA) Midlands Beer Competition. This award-winning streak has continued with further SIBA wins, and several CAMRA awards, including gold in the 2020 Champion Beer of Britain Golden Ale competition for the East Midlands, and micropub of the month in August 2019 for the Sorrel Fox in Mountsorrel.

Although during the pandemic Charnwood Brewery was no longer able to host on-site drinkers, they were able to continue to provide supplies to local outlets, as well as sell from their premises, along with offering an online purchasing option.

Charnwood Brewery awards and Platinum Jubilee blonde ale, 2022.

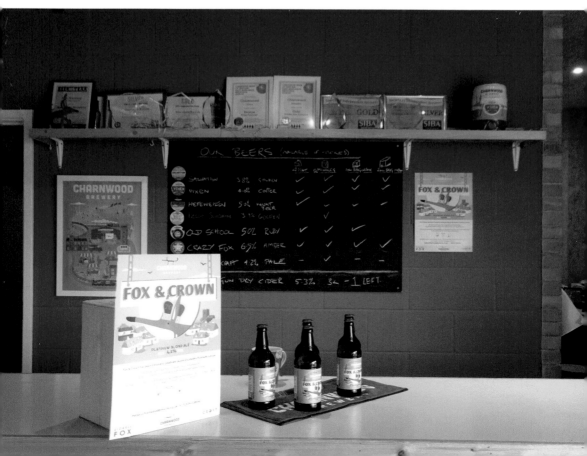

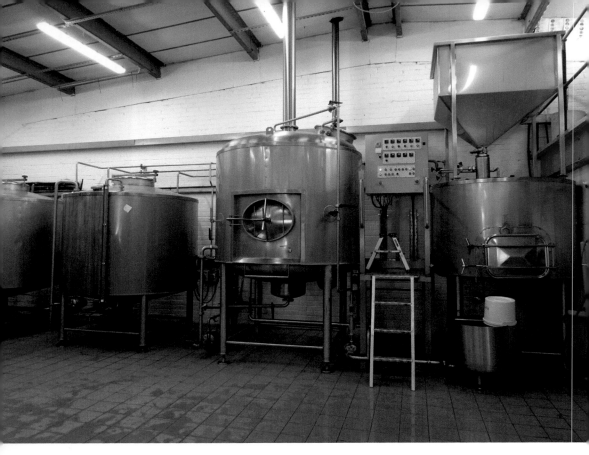

Inside the brewery, 2022.

24. Generous Briton, Ashby Road

Being very slightly outside the town centre, the Generous Briton was only infrequently the venue for auctions of land and property, although one such took place in 1854, when a dwelling house, with cow house and other outbuildings on Ashby Road was auctioned. The pub itself was up for auction in 1875, when it was described as consisting of a bar, parlour, taproom and kitchen, along with several bedrooms, good cellarage and brewhouse, and outside was excellent stabling with granary above.

Similarly, although inquests held within were few, several of interest include one in 1842, when the verdict returned was that the deceased had died by a visitation of God, caused by partaking of insufficient food and drink, despite the deceased being well-off. Another case, in 1849, was that of a young man who accidentally shot and killed himself whilst out with friends hunting down corncrakes. However, it is curious that the inquest into a drowning in the canal basin was held in the Generous Briton in 1877, for there were several venues much closer to the incident which might have been used. Cart accidents on the busy road outside the pub were often fatal, and it is surprising that the pub was still standing, when, in 1852, a practical joker sneaking some gunpowder from the landlord's flask proceeded to throw small amounts into the fire without realising that he was leaving behind a trail of powder, which eventually

Above: Generous Briton Regent Street view, 2013.

Right: Historic interior of the Generous Briton, 2019.

ignited, breaking his fingers, seriously injuring his head, and scorching the face of another customer.

The licence for the Generous Briton was regularly renewed, although in February 1937 this was deferred to the March licensing session as a notice had been served on the owners of the pub to deposit their building plans. A new building had been constructed to replace the ageing pub, and in March 1937, the licence was renewed, subject to structural alterations being carried out by 5 October 1937, resulting in the building we see today.

Sport has always been a feature of the Generous Briton. While in 1836 the venue hosted a pigeon shoot, more recently the venue has shown sport on large television screens, as well as participating in the local darts and dominoes leagues, and even having its own angling club. A regular pub quiz has been held and the pub has hosted live music events.

In 1977, the Generous Briton appeared in the CAMRA guide *Real Ale, Leicestershire & Rutland*, and in 2011, the venue became a freehouse. Since that time, it has served a wide variety of beers and gained several awards from the Loughborough and North Leicestershire branch of CAMRA – 2011 and 2012 Town Pub of the Year, and also in 2012, Pub of the Year. The pub was also added to the CAMRA list of historic pub interiors.

In recent years, the Generous Briton has undergone a number of transformations and refurbishments. 2011 saw an update to the interior, 2012 to the outside space, and 2017 saw new cellar cooling installed. On 1 March 2020, the Generous Briton closed for a planned refurbishment that was due to take three weeks. It cannot have been foreseen that a pandemic would mean the closure would be for much longer than planned, so it wasn't until 4 July that the venue re-opened, when even the pool table had gone contactless, and the exterior signs modernised. The opportunity was also taken to improve the pub's garden.

25. Harvester Wheatsheaf, New Ashby Road

At the beginning of December 1964, James Hole, brewers of Newark, opened a pub on New Ashby Road in Loughborough to serve the growing population in that area. The first landlords of this new establishment were Peter and Sylvia Morris, who had arrived here following four years as landlords of the Nag's Head in nearby Mountsorrel.

During the previous seven or so years, the brewery had been developing its idea of themed pubs, many of which were on the outskirts of towns, predominantly where new housing estates were growing up. Some of the earliest of these pubs were the Heron near Peterborough, opened in 1957; the Tudor Rose on the Mowmacre Hill Estate in Leicester, opened in 1959, and noted for its stained glass and low-relief panels; the Egyptian Queen at Blaby, adorned by imitation mummies and an Egyptian temple; the Greek Plough in East Goscote; and The Sea Around Us in Loughborough.

There have been numerous theories as to the origin of the pub name. Some believed it was based on someone saying 'it's like the sea around us' when the nearby Black Brook dam broke its banks and the water tumbled down into the lower areas of what is now the Old Ashby Road, way back in 1799! Another theory was that the name was

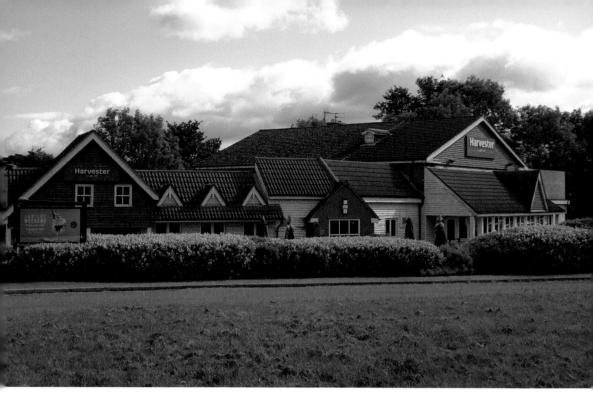

Harvester Wheatsheaf, 2022.

an ironic nod to the fact that, actually, the pub could hardly be any further from the sea than it was! Alternatively, perhaps the first landlords had something to do with the naming, or maybe the brewery surveyor, Richard Bradbury, or their designer Graham Boston? However, it seems the pub was named by Sir Oliver Welby, the chairman of the brewery, inspired by travels abroad with his wife.

Having gone down the route of a sea theme, the pub, which cost around £50,000, had three rooms, each with its own sea theme. There was a 'Boat Bar', containing a model of an ancient ship; a 'Shell Lounge' with tropical fish aquarium; and a 'Mermaid's Cavern'. There was also a concert room with a sprung dance floor and a Hammond organ, which formed the front of the pub, facing the main road, looking like a conservatory, or possibly a gold-fish bowl, with floor to ceiling glass panels. Included in the decoration were shells that Richard Bradbury's son had collected from the sea around the Caribbean especially for the pub.

The Sea Around Us was the destination for an evening mystery tour when in 1966 the landlady of the Anglesey Arms, a pub in Winshall, Staffordshire, organised a trip for many of her female customers. As well as visitors from afar, the pub naturally attracted visitors from the environs, and helped to foster a sense of community spirit. This spirit has seen the pub's clientele engage enthusiastically with fundraising events, like draws, including one for which the prize was a ride in a hot-air balloon, and selling trolley tokens, with proceeds going to various charities like the local Laura Centre in Leicester, which specialised in supporting bereaved parents and young children, and the national Make-A-Wish Foundation.

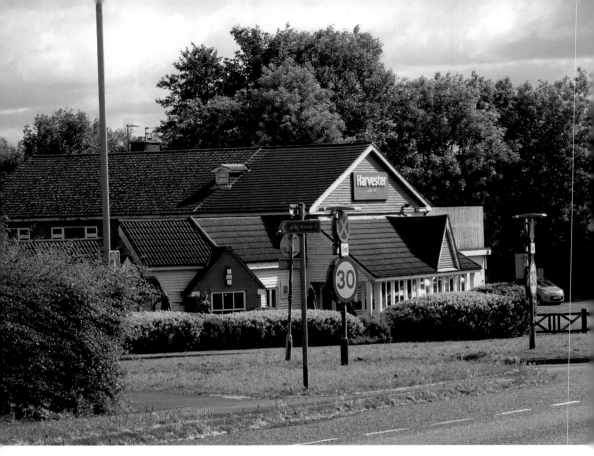

Harvester Wheatsheaf, 2022.

For a short while the Sea Around Us was known as Junction 23, perhaps reflecting its proximity to that junction on the M1, which was completed during 1965 and 1968, and which passes within about a mile of the pub, which is on a direct route into Loughborough. Junction 23 off the M1 is still a very busy exit, but in 1991, Junction 23, the pub, was renovated and renamed by a member of the public, and the Harvester Wheatsheaf has survived the pandemic of 2020–22.

26. Maxwells, Maxwell Drive

In the 1980s the Gorse Covert area of Loughborough began to be developed for housing, and in 1985 it was proposed to build a new pub to cater for the people in this area, at an estimated cost of £700,000. In 1986, the Bass, Mitchell and Butler brewery put in an application to transfer the licence from The Nelson public house in Market Place to this new proposed pub. Nearby pubs – The Warwick Arms, now a fast-food burger restaurant, the Gallant Knight, now a supermarket, and The Plough in Thorpe Acre – raised objections, and the application was refused. However, it was later approved, and by March 1987 local builders Moss were contracted to construct the new pub.

In late 1987 it was announced that the pub, which had actually cost around £750,000, had been named by the public and would be called Maxwells. Inside would

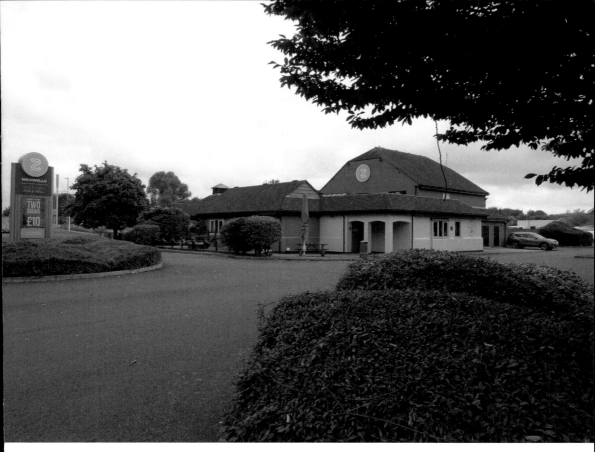

Above and below: Maxwells, 2021.

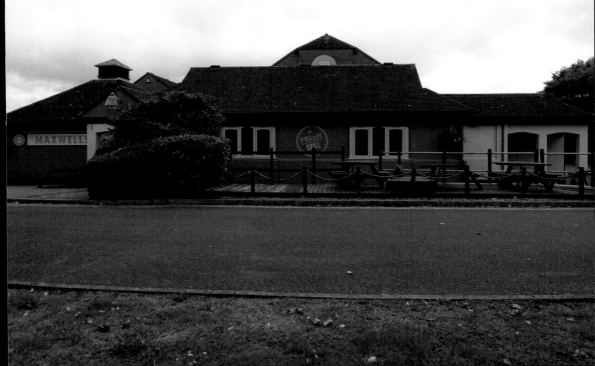

be a family room off the main lounge, with child-sized furniture and an outside garden and play area where children could run around safely. The pub finally was opened in February 1988.

Over the years, Maxwells has been the meeting place for the Charnwood Ladies Hockey Club to set off on their away matches, and the starting point for a dog walk, raising money for PAWS. It has held a children's drawing competition, with the prize being a day out at the American Adventure theme park, and has raised money for Dr Barnardo's by selling lottery tickets.

Maxwells – along with the now closed Lonsdale Hotel on Burder Street – was the first venue to hold a karaoke event in Loughborough, in April 1991. Such was the success of this event that in the summer of 1991 the local newspaper, the *Loughborough Echo*, launched a competition to find the best karaoke singer in the area! Ten years later and karaoke was still going strong, and Maxwells took part in a competition – Pub Stars, run by Arena pubs – to find the best local star, through heats and then finals, the winner then competing in a regional final.

Like all other pubs in Loughborough, and across the country, Maxwells was closed during the pandemic. Once re-opening began, their outside garden area allowed them to again serve the people in the Gorse Covert area, for whom the pub had originally been built.

27. Moonface, Moira Street

In 2013, the building now occupied by Moonface, Brewery & Tap was a small, partly renovated red-brick building, used at some point as a warehouse. By May 2018, it had been acquired by the microbrewery, and planning permission and a licence had been granted. The interior was renovated, the front door was painted a bright royal blue, stocks were delivered, the exterior sign was mounted, and Moonface opened to the public in October 2018.

During its opening year, before brewing took place on site, a wide range of guest beers was made available. These regularly changing guest beers, which have included ones like Shipstone's Original, are now available alongside Moonface's own beer, like Drama Queen, Citra 4.5, Pakes's Pale, London Porter, and Hlaf. In May 2020, Moonface teamed up with a community project in Sileby called Complete Wasters to produce a beer from leftover, stale – but not mouldy – bread. The resulting beer was called Hlaf, which is an Old English name for a loaf of bread. Hlaf was sold at the Moonface premises and out at events, which included outdoor film showings in Sileby during August 2020.

During the pandemic, although as per government instruction, the building was closed, the brewery was able to offer collection from its premises for consumption at home. In July 2021, Moonface opened up again, and their drinks were included in the offerings at such events as the beer festival in nearby Quorn and at some of the Great Central Railway events.

Moonface has been awarded the Loughborough and North Leicestershire branch CAMRA Pub of the Year award in 2020 and 2021, and was a joint runner-up in 2022. In 2021, like the Needle & Pin, it also received the branch Special Award for Services

Above: Moira Street building in 2016.

Below: The blue door of Moonface, 2022.

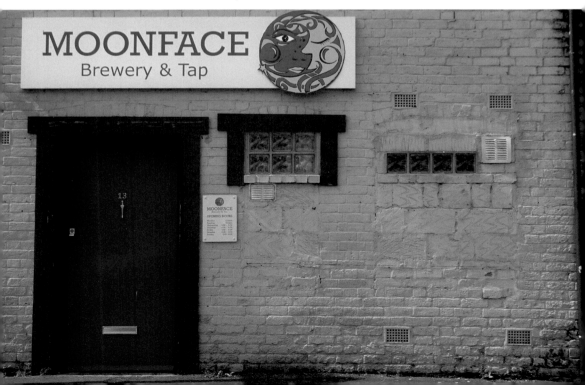

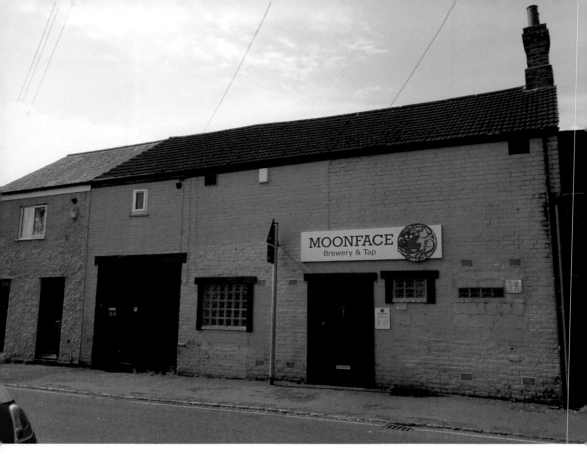

Moonface in 2022.

to Customers during the pandemic. It was in Moonface that the local CAMRA branch held its first in-person meeting since March 2020, when a pleasing number of people attended. Moonface also appears in the CAMRA *Good Beer Guide*.

28. Old English Gentleman, Ashby Road

In 1851, the Old English Gentleman was described as a beerhouse, run by Thomas Wright, and it was one of the venues for meetings of the Licensed Victuallers' Association. A later landlord, Mr Cooper, provided the refreshment buffet at the annual Hathern Floral, Horticultural, and Celery Society Show, and in 1883 he hired a refreshment tent and served refreshments at an event in Quorn.

It was perhaps inevitable that as more and more housing was built in the area around Ashby Road, and as the population increased, that there would be more inquests held at nearby pubs, of which the Old English Gentleman, along with the Generous Briton, was one. Between 1890 and 1912, there were deaths to be investigated at each end of the spectrum, from ten-year-olds to seventy-three-year-olds, and men and women of all ages in between. Several of the inquests were of people who lived on nearby Granville Street, and on one occasion the inquest was into the death, following an accident, of the landlord's own wife.

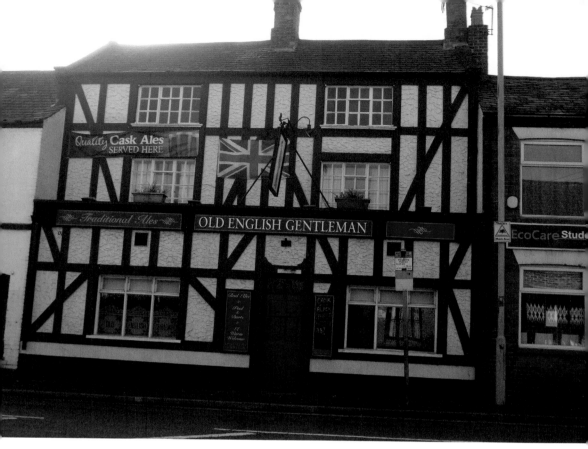

Old English Gentleman, 2013.

More cheerfully, sport has played a big part in the life of the pub, which at one time was the headquarters of the Loughborough and District Pubs and Clubs Darts League. A marathon darts competition in 1974, held at the Old English Gentleman, raised £50 towards the cost of a television for the Loughborough General Hospital Nurses' home on Park Road. A player from the pub was one of six Loughborough darts champions representing town pubs taking part in the county final of the Winners Matches/Star Pub and Club open championships. In the 1960s, the Loughborough United Football Team Supporters Club was based in the Old English Gentleman. On Boxing Day 1989, players from the pub took part in a charity football match and raised £500 for the new RNIB College on Radmoor Road.

Other fundraising events have included a raffle which took place over a few months in 1985 and raised enough money to buy a colour television for Glebe House (a charity supporting adults and children with learning difficulties) and twenty-eight sets of breathing apparatus for the staff at the Loughborough Ambulance station. Other leisure activity has included playing in the local whist league, in the Loughborough and District Quiz League, and in the Shepshed and District Games League, which involved traditional pub games like cribbage and dominoes.

The building itself has not changed much down the years. In 1885, plans were submitted for alterations to the shed and other buildings, which were approved,

subject to certain amendments. In 1939, several pubs in and around Loughborough were deemed to have structurally deficient or unsuitable premises, and the Old English Gentleman was one of these. The licence renewal was delayed, until improvement plans were provided. However, Mr Barson, the licensee, said that his customers wanted to preserve the character of the pub, which had only had three tenants in the past forty years, and many customers had been loyal all that time, with no complaints. It was finally agreed that the licence would be renewed, provided provision was made for hot and cold water for the washing up of glasses. In 2015, a visitor to the pub described it as having a games room to the left, where pool and darts could be played, and in 2018, the garden area was improved. The pub closed for a period immediately prior to the pandemic.

At the sign of the Old English Gentleman, 2020.

29. Paget Arms, Paget Street

The Paget Arms, a fine red-brick building on the corner of Paget Street and Oxford Street, was at the very centre of a Victorian housing development for workers in Loughborough's expanding industries. Part of the estate belonging to the Paget family was sold to enable the building of houses, as was part of the Storer estate. Construction began in the mid- to late 1880s and resulted in the grid-like streets including Cumberland Road, Storer Road and Oxford Street. The idea of the need for a public house to serve the people of the estate was one that caused much consternation amongst the nearby establishments.

In August 1887, George Trease, a manager of the Midland Brewery Company on Derby Road, applied for a licence to sell beer on a premises which was within 250–300 yards of the George IV Inn (now demolished), the Generous Briton, and the Station Hotel. The proprietors of these premises were opposed to the granting of such a licence, and the application was refused, the brewsters basing their decision partly on the proximity of the other 'houses', and the conviction that one public house for every 193 inhabitants was ample!

A year later, George Trease again sought a licence, and it was noted that the request was specifically for a new premises that was about to be erected at the corner of

Paget Arms from Paget Street, 2019.

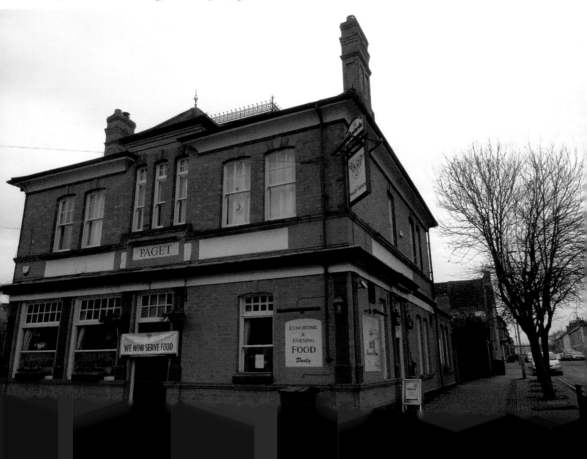

Paget Arms from Oxford Street, 2019.

Paget and Oxford streets. There were now about 250 houses on the Paget estate land, and almost 1.5 miles of properties, so the new pub in the exact centre would be of huge benefit to those local inhabitants who considered that 200 yards to the nearby Station Hotel was too far to walk. Perhaps what swung the vote with the brewsters was the proposal to move the licence from the New Inn on Baxter Gate, as they considered there were far too many licensed premises on that road, and so the new licence for the Paget Arms was granted. In February 1890, the Midland Brewery advertised several public houses to let in Loughborough and the district, and it's possible the newly constructed Paget Arms was one of these. By the time of the 1891 census the licensee of the Paget Arms was Isaac Unwin, who remained here for at least twenty years.

Like many other such establishments, as well as providing ample refreshment for people, the Paget Arms premises was the venue for numerous inquests into deaths. Calamities also happened in the area, and in June 1916, a huge thunderstorm hit Loughborough, which lasted nearly an hour and caused severe flooding in the streets. During the storm, a brick chimney on the Paget Arms was struck and the brickwork fell through the roof of the building, melting the leadwork at the base of the chimney. Thankfully, no casualties were reported. Fundraising activities have also been held, and in 2010, the pub produced a calendar, called 'The Paget Undressed', taking its

inspiration from the film *Calendar Girls*, which aimed to raise funds for LOROS, the Leicestershire hospice.

Recently, one of the pub's rooms has been decorated with old sporting equipment, perhaps a nod to events held outside the pub, like the 7-mile cross-country race that took place in December 1906 between teams from Loughborough and Leicester Fosse Road, a race that was won by the Loughborough team. This sporting theme has been continued today, and the Loughborough Town Hockey Club, which celebrates its 125th anniversary in 2022, and which meets at Loughborough University, have their after-match teas at the Paget Arms.

Initially part of the Midland Brewery Company, the Paget Arms was associated with Strettons Brewery of Derby which took over the Midland Brewery, and later with the Leicestershire brewers Everards, whose founders at one time lived at Nanpantan Hall in Loughborough, once owned by the Paget family. After a period as part of the Steamin' Billy chain, the Paget Arms is once again an Everards establishment.

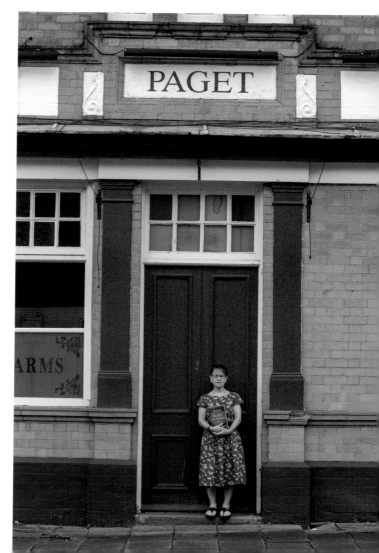

Entrance to the Paget Arms, 2019. (Photo credit: Tom Dyer-Hill)

Today the Paget Arms finds itself at the heart of what is known as the Golden Triangle, an area of Loughborough that is popular with students due to its proximity to both the university and the town centre.

30. Peacock, Factory Street

The Peacock Inn is situated at what is now the end of Factory Street, although at one time the street was somewhat longer. Very close to the Peacock were a number of hosiery factories, and it was here and in adjacent properties that the inventor of the 'Cottons patent' knitting machine, William Cotton, lived, and a heritage plaque can be seen on the adjoining property.

Like other pubs in the nineteenth century, the building was the venue for auctions; for example, in 1841 when eight dwellings facing onto Queen Street were for sale. The Licensed Victuallers' Association also used to meet at the pub. Inquests were also held within, and in 1899 an inquest was held into the sad death of a young boy who accidentally swallowed a damson stone.

Over the years, fruit has played an important role in the life of the Peacock Inn. In the 1860s, the pub was the venue for the regular meetings and shows of the Celery Society and the Gooseberry Growers Society, the latter having previously taken place at the Pack Horse (now the Organ Grinder), and the former later moved to the Rose and Crown (now the Loughborough Arms), as well as general horticultural shows. The landlord, Richard Smith, would erect a tent at the back of the pub, and in September 1865 the tent was lit with a new type of gas lighting which had been brought to the pub earlier in the year and was being tested on Mr Smith's premises.

Mr Smith would often provide refreshments at the pub after events like a cricket match between employees of the Cartwright and Warner factories, or at his own establishment for events taking place nearby in the Elms Park owned by the local hosiers, Warners. In the early 1900s, landlord Llewellyn Watkins, who had previously been the landlord at the Greyhound on Nottingham Road, also provided outside refreshments when he catered for the Kingston on Soar Horse Show, although by 1909 he was auctioning off his extensive collection of catering equipment.

Mr Watkins also did a bit of fundraising, or, more specifically, his terrier called Kitchener did! The dog would regularly perform tricks in the pub, and in 1906 raised money for the local hospital (£2 16s) and for the Royal Lifeboat institutions (5s 3d). More recently, fundraising events have included inter-club competitions to raise money for a kidney machine, and darts matches to support the local Ashmount School.

The Peacock was listed in CAMRA's 1977 guide, *Real Ale, Leicestershire & Rutland*, and in 2008 was voted the Loughborough and North Leicestershire branch of CAMRA Mild Pub of the Year. Today, the pub now offers bed and breakfast, has a large beer garden, and holds a variety of events. Traditional pub games, like skittles, are still on offer, and the windows of the pub still bear the signs of the Offilers Brewery, to which the pub was tied.

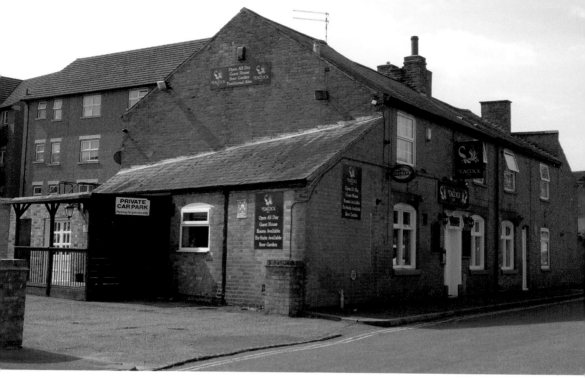

Above and right: Peacock, 2022.

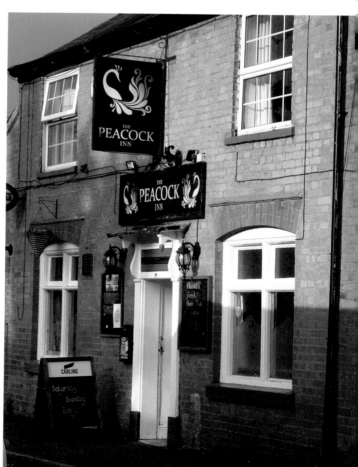

31. Plough Inn, Thorpe Acre Road

Today we think of Thorpe Acre as simply being part of the town of Loughborough, in the direction of Hathern. However, at one time Thorpe Acre was a separate place, once joined with Dishley, and the Plough Inn was at the heart of the village centre. In March 1828, the inn was the venue for an auction of dwelling houses and tenements, along with stocking-makers' shops, yards, and gardens when Mrs Hopewell was the landlady. As was the practice at the time, the pub was also a venue for inquests into deaths in the area, like the death of John North, a seventy-eight-year-old labourer in 1831 who had gone to bed in seemingly perfect health, but died of natural causes during the night. The inquest into the death of Mr Evans, however, who in August 1853 had been travelling in a phaeton which overturned, returned a verdict of accidental death. The landlord in 1853 was William Garton, and as he was also a baker, the pub also served as the local bakery. William Lawrence, who followed Garton as landlord, was an 'out' Chelsea pensioner, collecting his pension from a local agent of the Royal Hospital, Chelsea.

The Plough also hosted many meetings of the Licensed Victuallers' Society (later the Licensed Victuallers' Association), at which skittles were played, quadrille bands entertained, and customers engaged in singing. In June 1856, the *Leicestershire*

The Plough at Thorpe Acre on the re-routed road, 2021.

Mercury, reported on one such meeting, saying that the members were 'much gratified with their rural excursion', especially since the beautiful weather meant they could enjoy their meal in the garden, amongst the delightful fragrance of flowers and foliage.

Like other similar establishments, the landlords of the Plough were required to undertake various alterations and renovations in order to renew the licence. In 1901, when the pub was part of the James Eadie brewery and the landlord was John H. Read, the local architect, Willie T. Hampton, designed the alterations, and once these were completed the licence was renewed.

Eventually, the small village of Thorpe Acre became surrounded by housing developments, mostly constructed in the 1950s and 1960s, and at some point the road layout was changed, so the Plough now sits with its back facing onto the road, its most impressive and substantial garden being hidden from passers-by.

For many years, the Plough has fielded its own football team, and in recent times this team has taken part in the Charnwood Sunday League, and the darts teams have played in the Sileby Legion darts competition. Fundraising events have also been held in the pub, and in 2000 the Plough was linked with other village landmarks – like the church, the green, the White Bridge, Jubilee Park, the Black Brook and the Stonebow Bridge – in a Thorpe Acre Heritage Trail, created by the community to mark the millennium.

The front of the Plough at the back! 2022.

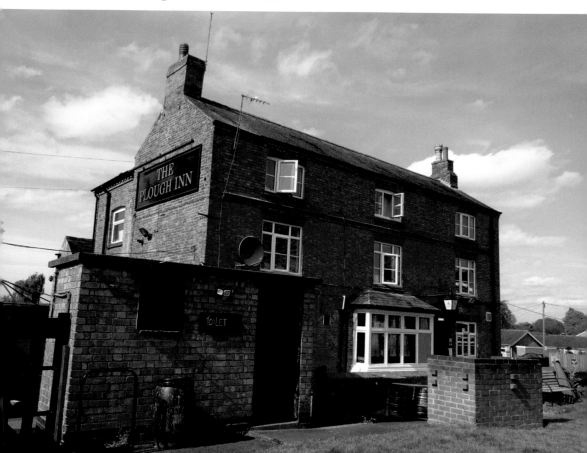

Above: The extensive garden at the Plough, 2022.

Below: Inside the Plough, 2022.

More recently, the Plough has seen several changes of management, and after a period of closure during the pandemic of 2020, and into 2021, it re-opened on 16 July 2021, but temporarily closed again in May 2022 when the landlords moved on.

32. Priory, Nanpantan Road

On approaching the Priory from any direction – along Snells Nook Lane, Woodhouse Lane, or Nanpantan Road – you'd be forgiven for thinking you'd suddenly come upon a fairy-tale French chateau, for that is how the pub looks and how it has been described. Also described as a roadhouse and named after the nearby Ulverscroft Priory, this almost stately looking building with its corner turrets and architecturally impressive appearance is perfectly placed on the very western edge of Loughborough, towards the Charnwood Forest, at almost the highest point, with a commanding view down into the Soar Valley below.

When the Priory opened as a Home Ales venue in 1936, the first landlords came from Sutton on Sea, near Mablethorpe, where they had been managing the Jolly Bacchus Hotel, a large, former coaching inn, and house for traders and sea folk. Strangely, the new landlords in 1953 also came from Sutton on Sea, where they too had been managing the Jolly Bacchus, then simply named the Bacchus. By 1977, the Priory was included in the CAMRA guide *Real Ale, Leicestershire & Rutland*.

The Priory from Snells Nook Lane, 2014.

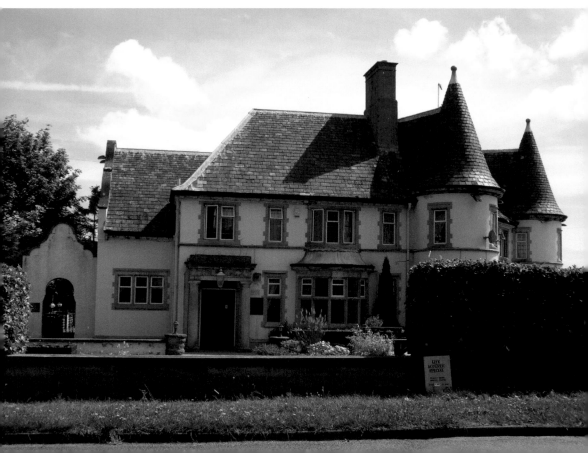

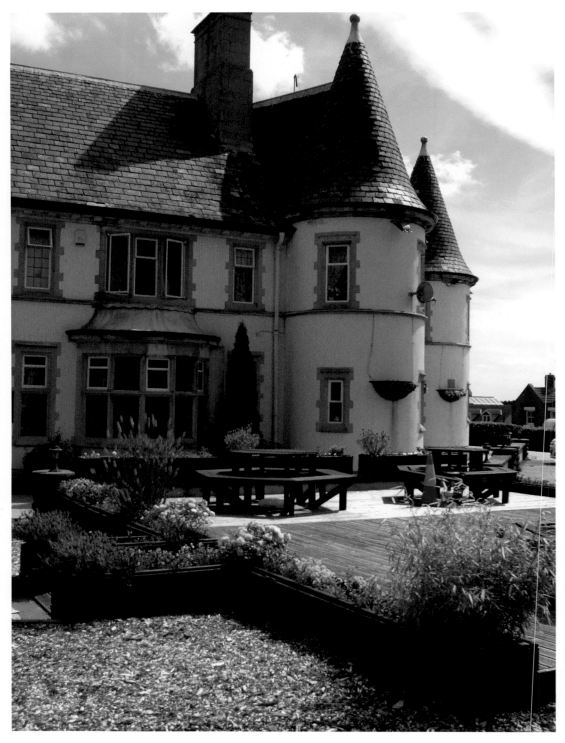

The Priory, 2014.

The pub has been the meeting place for a wide variety of groups, including one group called the Broadway Ward Women's Unionist Association, who, following their outing to the Leicestershire countryside, spent an hour dancing in the ballroom of the Priory before setting off for home. The Charnwood Group of the Women's Institute met at the Priory in 1958 to hear a talk from the matron at the County Children's Hostel on her work, accompanied by an exhibition of antique silver. In 1966, following the inaugural meeting of the Ladies' Lifeboat Guild, which was held at the King's Head, one of the group's first events was a successful dance at the Priory. This followed a watery theme, the room being decorated with fishing nets, and a swimsuit parade was facilitated by local high street 'department store' Russell Smith. The event raised £86 11s 6d for the charity. Perhaps this event was also influenced by the recent opening of the Sea Around Us (now the Harvester Wheatsheaf)?

Fundraising events have been a feature of the Priory throughout its existence, and Priory Mencap held regular horticultural shows at the pub, where there would be flower displays, stalls, food, and a variety of music events, the entrance fee from many of which were donated to Oxfam. The Priory also provided space for many a wedding reception, including that of Leicester Tiger's rugby player George Cullen, who married at the parish church in 1955.

The building itself has undergone a variety of changes, and in 1990, after spending over £100,000 on refurbishing, the Home Brewery's advertising campaign described the pub as a landmark! The rooms within – the Cloister, Sanctuary Bars, and the Charnwood Suite – were suitably modernised, whilst retaining a feeling appropriate to such a magnificent building. In 2004, the Priory was added to the Borough Council's register of locally listed buildings.

Following a period of closure during the pandemic, the Priory is now fully open.

33. Ring O' Bells, Derby Road

At the time it opened in 1956, the Ring O' Bells found itself at the very edge of Loughborough, the last refreshment stop on the Derby Road before leaving the town boundary. The development of Thorpe Acre hadn't yet happened, and the Plough really was a village pub, as the building of Maxwells was still over thirty years away. As an estate pub, tied to the Home Ales brewery, the Ring O' Bells served the residents of the area, where the houses had been built to home workers from the successful Brush company. According to Wells, the licence came from the closure of the Nag's Head, Swan Street, and the pub is locally known as 'The Clangers'.

Down the years, the pub has fielded teams in darts, including playing in the Loughborough and District League, and the Barrow Fours Summer League, and even the World Grand Prix. Teams from the Ring O' Bells have also played in the Charnwood Sunday League football, in the Loughborough Whist League, and numerous pub quizzes.

Live music has also featured at the pub, and its community spirit has seen the pub staff supporting the campaign for lower-priced soft drinks, as well as participating in many fundraising events. Such fundraising has included fancy dress football matches

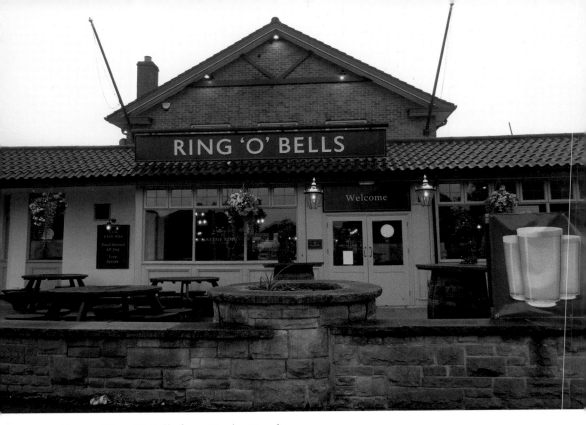

Above: Ring O' Bells from Derby Road, 2020.

Below: Ring O' Bells from Knightthorpe Road, 2021.

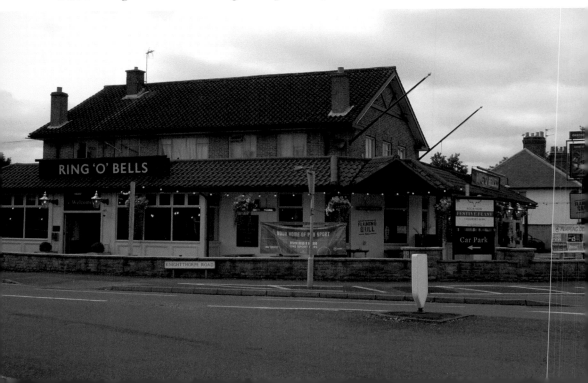

and cycle rides, and one customer even spent four hours in a bath of cold water in the bar of the pub to raise money for Red Nose Day.

In 1987, Home Brewery, as Home Ales had become, applied for permission to make alterations and extensions to form entrance lobbies, and to demolish an existing workshop to provide additional car parking and access to Knightthorpe Road. By 2011 the pub had become part of the Flaming Grill chain, serving Greene King, and following a period of closure during the pandemic, has re-opened and now offers a beer garden, big screen sports, food, Wi-Fi, and welcomes coach parties.

34. Royal Oak, Leicester Road

When William Walpole, a stonemason by trade, became the landlord of the Royal Oak in 1829, the establishment was situated on the busy turnpike road which ran from Leicester to Loughborough, overlooking what was then known as Paget's field or park, now Southfields Park. By 1832, Mr Walpole was selling up, and there was so much to sell that auctions were held on both 31 December 1832 and 1 January 1833. The building itself was not for sale, but the brewing equipment available included a large mash tub, a cooler, a copper, two iron boilers, working vats and brewing tubs, casks, along with around 300 gallons of what the auction catalogue described as 'excellent ale'. Household furniture was also auctioned, as were effects associated with the trade of stone masonry, like stone troughs, headstones, rough stone, and many tools. As if that weren't enough, also included in the auction were a cow, a couple of pigs, and a stack of hay!

Other auctions were held at the Royal Oak, including that of properties on the nearby Queen Street, in 1849. Inquests also took place in the pub, including that into the death of brickmaker Charles Richards, who was trampled to death by his horse which had reared up and fallen over when frightened by lights shining from a machine house in 1851.

The Royal Oak, along with other local establishments, was also the setting for group meetings. In February 1849, many friends of the landlord, Arthur Hatfield, spent an enjoyable evening together in his pub, so much so that they agreed to reconvene the weekly social gatherings of the old Conservative society, which had lapsed. More recently, the year 2000 was the 20th anniversary of the BBC Children in Need Appeal, and in support of this the Royal Oak held a sponsored darts and pool match. Darts had been a popular pastime at the Royal Oak, and in 1969, a member of the darts team made it to the Midland final of the *News of the World* individual darts championship, held at the Matrix Hall in Coventry, where he represented Leicestershire, although the match was lost, 2-1, to a player from Staffordshire.

An extensive refurbishment of the pub took place in 1998, when new landlords were appointed. They were aware of the local ghost, said to be a shift worker from days gone by, who was nicknamed the Galloping Major. At precisely 12.28 a.m. every night, he would knock twice on the pub door, a code that would have seen him welcomed onto the premises after closing time! The new landlords hoped he would approve of the changes they had made!

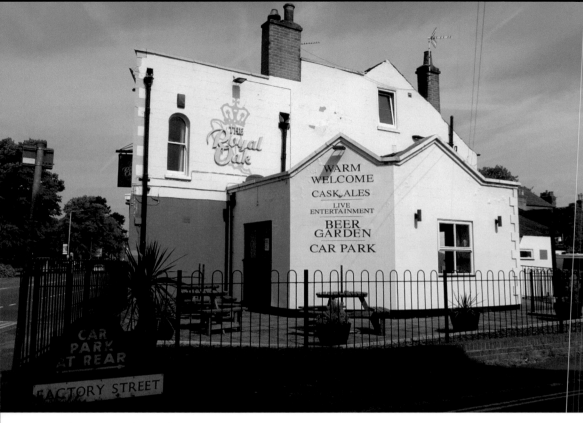

Above: Royal Oak from Factory Street, 2022.

Below: Royal Oak from Leicester Road, 2022.

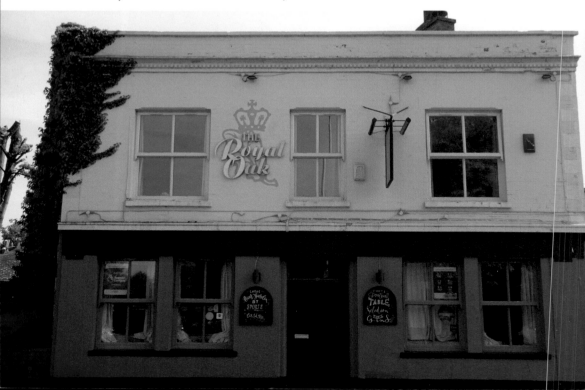

Today, the Royal Oak, situated next to the award-winning Holywell Guest House, which was the former rectory to Holy Trinity church, and at the opposite end of Factory Street to the Peacock Inn, retains its fresh look and its outlook over Southfields Park, which has itself been the subject of a recent refurbishment, with new, striking black entrance gates.

35. Tap & Mallet, Nottingham Road

In April 1844, when the Three Crowns was up for auction on its own premises, it was described as a newly erected and commodious dwelling house called the Three Crowns, in excellent condition, with a yard, garden, stables and other useful out-offices, and in the occupation of James Hind Keightley, who had previously been at the Duke of York pub. Keightley remained associated with the premises until around 1860, when the licence for the Three Crowns was transferred to James Hubbard, and two years later, Keightley died. In 1866, the licence was transferred from Hubbard to Alfred Collard, although the latter stayed only a couple of years before the licence was transferred, this time to Samuel Smith.

In September 1868, the Three Crowns was again up for auction at the Three Crowns, as Lot 4, this time described as old, rather than new. The public house had yards, a brewhouse and outbuildings, and was in the occupation of Samuel Smith. The auction details stated that the purchaser of this Lot was required to build a division wall against Lot 3, which was a property occupied by Elizabeth Bowles, along with two cottages in the yard, occupied by Samuel Warren and Thomas Wegdale, and the purchaser of Lot 3 was obliged to erect a new privy.

Before taking over the Three Crowns, Samuel Smith, who was born in Thurmaston, had been a 'pedestrian', taking part in walking and hurdling matches. In 1848, Smith's brother, John, known as the 'Regent Street Pet', ran the Derby Arms pub in Turnham Green, a place where the brothers took part in such matches. In 1850, both brothers had spectated at the race between Westhall and Roberts along Ashby Road. Samuel Smith occupied the Three Crowns until 1877, and during this time introduced pub tokens bearing his name, before the licence passed to William Derry Perkins.

In 1922, permission to alter the Home Ales venue was granted, despite concerns regarding congestion in Nottingham Road, particularly as there were many licensed premises in the area: in a half-mile stretch from the Midland Mainline station to The Coneries, there were around nine pubs situated actually on the route. In 1977, the pub was listed in the *Real Ale, Leicestershire & Rutland* CAMRA guide, and in 1993 the pub was re-branded and renamed the Tap & Mallet. In 1994, the landlord cut the opening ribbon at the Loughborough Students' Union Real Ale Society Coastal Beer Festival. The Tap & Mallet was winner of the CAMRA Loughborough and North Leicestershire branch Mild Pub of the Year in 2007, and Town Pub of the Year in 2010, as well as being highlighted in the CAMRA Pub Heritage list of Historic Pub Interiors.

As with many other local pubs, as the Three Crowns, the pub was a venue for auctions of land and property, for inquests, was a meeting place for a variety of groups, and a venue for fundraising events. The pub fielded teams in pool, darts, dominoes,

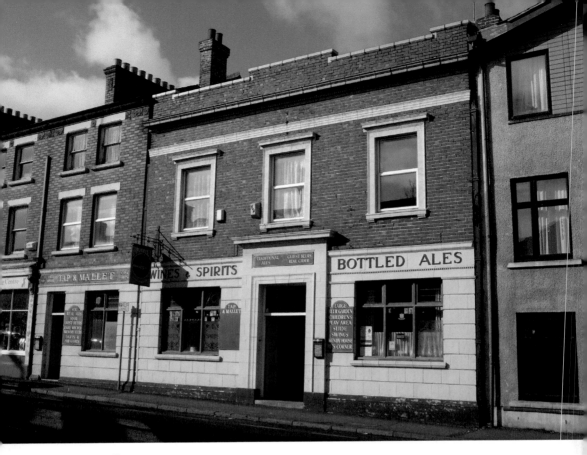

Tap & Mallet, 2015.

and whist, winning the whist Priestley Cup in 1987. One of the pub's darts players, who also played for the Peacock Inn and was part of the county team, was the only Loughborough player to be selected to play in the Midland Counties team against East Anglia in 1991.

Since the congestion on Nottingham Road mentioned in 1922, the Tap & Mallet has been the sole remaining pub on this road for many years, but closed its doors a short time before the pandemic began.

36. Toby Carvery, Forest Road

When the area around The Holt, a large house used by Loughborough College as halls of residence, began to be developed as a residential area, the new inhabitants were assured that there would be no trading or manufacturing in the vicinity. However, in July 1934, the James Eadie brewery put in an application for a licence for a pub on the 'Holt estate', in return for surrendering the licence of the Eagle Inn on Church Gate. It was common practice to close one pub and transfer the licence elsewhere, as was the case with the Bull's Head on High Street which closed, and the licence was transferred to the Bull's Head, Shelthorpe (now a fast-food burger outlet). As the proposal for the Holt area went against the plan for a purely

residential development, the application was turned down, as it was again, in February and March 1935.

It wasn't until 1962 that the proposed pub was built and the licence finally granted, a year after the Bass Brewery had merged with Mitchells and Butler. The new pub, the Forest Gate, quickly established itself as a popular venue, and by 1963 was hosting the final of the *Leicester Evening Mail* bridge trophy competition. In 1973, the pub was also the venue for a property auction, something which happened far less frequently in the twentieth century than it had in the nineteenth. By 1977, the pub was listed in the *Real Ale, Leicestershire & Rutland* CAMRA guide.

In 1985, Bass Worthington launched a competition to complete a pub trail by having a card stamped by each venue visited. In Loughborough and its surrounding areas there were forty-one establishments to visit, and one lucky person, who, with friends, visited them all within two weeks, won a holiday for two, the prize being presented at the Forest Gate pub. Presentations were also made in 1985 at the Forest Gate to the

Toby Carvery, Forest Road, 2021.

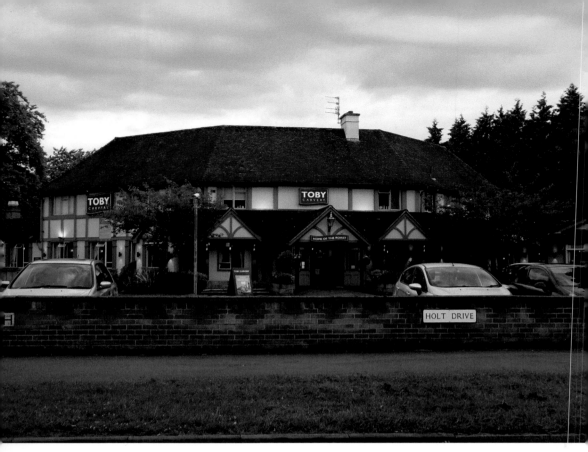

Toby Carvery from Holt Drive, 2021.

winner of the Bass 200 Yearling Race, a pigeon race sponsored by Bass Worthington. The Brush organised the event, and the winning pigeon completed the 210-mile journey in just over six and a half hours!

A re-branding took place, the Forest Gate becoming known as the Toby Carvery, and in 1987 an application was submitted to display nine externally illuminated fascia signs and four free-standing non-illuminated signs. The pub offered business lunches, early bird evening meals, a space for parties, and held an entertainment licence – agreeing to keep the windows closed during events, in order not to disturb the neighbours! In 1998, the pub underwent a £650,000 refurbishment, and the following year added a new entrance porch, made some external alterations, and added an extension to house a cold store.

Fundraising events have included a donation to Rainbows, the local children's hospice, for every gallon of custard poured. The car park has been used by the local police service to offer advice and cycle checks to local cyclists. In 2017, the pub was the venue for the first meeting of the Charnwood Armed Forces and Veterans Breakfast Club, designed to provide mutual support and friendship for veterans and their families. This group met every second Saturday of the month, but during the pandemic, when the pub was closed, was unable to meet until the re-opening in August 2021.

Toby Carvery, 2021.

Bibliography

The Good Beer Guide 2021 (St Albans: CAMRA, 2020)

Nicholson, Robert, *Nicholson's Real Ale Guide to the Waterways* (London: 1976)

Real Ale, Leicestershire & Rutland (CAMRA, 1977)

Swift, Eric *Inns of Leicestershire* (Leicester: Leicester Research Services, 1976)

Wells, William *Billy's Book of Loughborough Boozers* (Loughborough: Panda Eyes, 2013)

Acknowledgements

Thank you to landlords who have supported me during the writing of this book, and who have enthusiastically welcomed me to photograph them and the interiors of their venues for inclusion. Thanks also, of course, to family and friends.

About the Author

Lynne has written three books for Amberley: *Loughborough in 50 Buildings*, *Secret Loughborough*, and *A–Z of Loughborough*.